CHINA PAINTING PROJECTS

with

SHEILA SOUTHWELL

To a Lady on her passion for old china

What ecstasies her bosom fire
How her eyes languish with desire
How blest how happy should I be
Were that fond glance bestowed on me
New doubts and fears within me war
What rivals near? a china jar
China is the passion of her soul
A cup, a plate, a dish, a bowl
Can kindle wishes in her breast
Inflame her joy, or break her rest

Husbands more covetous than sage
Condemn this china buying rage,
They count that woman's prudence little,
Who sets her heart on things so brittle.

John Gay 1685 – 1732

CHINA PAINTING PROJECTS

with

SHEILA SOUTHWELL

BLANDFORD

Blandford Press

an imprint of
Cassell plc
Artillery House, Artillery Row
London SW1P 1RT
Copyright © Sheila Southwell 1987

First published 1987

Reprinted in paperback 1988

British Library Cataloguing in Publication Data

Southwell, Sheila
China Painting Projects with Sheila Southwell
1. China painting
2. Title
738.1'5 NK4605

ISBN 0 7137 2088 3

Distributed in the United States by
Sterling Publishing Co, Inc,
2 Park Avenue, New York, NY 10016

Distributed in Australia by
Capricorn Link (Australia) Pty Ltd
PO Box 665, Lane Cove, NSW 2066

Typeset in 11/13pt Plantin by Word Perfect 99 Ltd.

Printed in Great Britain by Purnell Book Production Ltd,
Member of the BPCC Group.

*This book is dedicated to my husband Alan
who has been a constant source of encouragement in the months
it has taken me to write it.*

Contents

Acknowledgements

Thanks go to Lenham Import & Export Company for the plate and vase stands used in this book. Photography by Alan Southwell, who gratefully acknowledges the help and advice given by Peter Faro and Paul Cudjoe of Brighton Polytechnic.

Preface

My previous book *Painting China & Porcelain* was written to provide basic information on the many and varied techniques of china painting and included 'in-depth' information on the necessary materials and their uses. It included chapters on colours, lustres, enamels, raised paste gilding and firing.

In this book, whilst the basics are not neglected, the chief emphasis is on projects for you to paint, with step-by-step instructions. I have included one or two old favourites, such as roses and chrysanthemums. Whilst these are always popular with china painters, I have endeavoured to choose more unusual subjects to encourage, stimulate and develop further your techniques. Also included as a bonus is a Glossary of china painting terms. Many of these terms confused me when I was a beginner and until now most books have failed to explain them.

I do hope you will enjoy the book and be tempted to try some of the more unusual subjects.

Happy Painting

Sheila

Porcelain ~ a brief history

Porcelain was first made in China as long ago as 700 AD where the method of its manufacture was a closely guarded secret. European potters after seeing pieces brought back by travellers from the Orient tried unsuccessfully for several centuries to copy this lovely ware. It was made in Germany by the Meissen factory in 1709 but despite attempts to keep it a secret it was not long before factories all over Europe were making this hard paste porcelain, many of the best examples coming from Germany, France and Italy. In England some of the early factories were Bow, Chelsea, Worcester, Derby and of course the Plymouth Porcelain Factory in 1768.

Bone china is a type of porcelain with the addition of bone ash and a patent for this was taken out by Thomas Frye of Bow in 1748. This date marks the first known use of bone ash with porcelain, though it had been used earlier as an ingredient for Milchglas (a milky looking glass) which was made in Venice and was made as an imitation of porcelain and so called *porzellanglas*. The manufacture of bone china quickly spread to other factories and a hybrid paste containing china clay and stone was adopted. This was covered with a lead glaze and was introduced by Spode at Stoke on Trent in the late eighteenth century, becoming standard English body during the nineteenth century.

Why the concentration of factories in Stoke on Trent in Staffordshire? During the seventeenth century British pottery industries developed in regional areas where large groups of potters worked together. The most important area was in North Staffordshire, geologically ideal for the pottery industry, as the local rock yielded suitable clays, marl, grit and lead ore for glazing and an abundant supply of coal, needed to fire the potter's kilns. The soil of the coal measures in this area was agriculturally poor and offered farmers little reward for their labours, but the incentive for the potters to utilise these natural assets was strong and the English Potteries were born.

Originally of course everything was painted by hand and each factory had its own team of artists, some of whom specialised in a single subject e.g. Wm. Billingsley who painted roses and worked at Derby, Worcester and Coalport, and John Brewer of Derby who painted military camp scenes. However, with the invention of overglaze printing and later, lithographic printing, handpainting has gradually diminished and today less than 1% of china and porcelain available for purchase in the shops is handpainted. It is important for us as china painters to improve standards and pass on what we know to future generations − our precious fine art must never be allowed to die as so many others have done.

Part 1
INTRODUCTION

An introduction to materials and techniques

Here is a list of supplies you will need to start china painting – many of them will last for years, providing they are cleaned after use and cared for in the proper way; this applies particularly to brushes, which can be very expensive to buy. In the glossary at the end of this book I discuss the materials and their uses in detail.

Colour manufacturers often refer to individual colours by the name, e.g. Copen Grey or Bakers Brown, which can be misleading as the same colour may have several names. Beginners often think that to obtain good results they must have this exact colour: the more experienced painter will realise that the name refers to a certain shade and so for this reason in the book I refer to a general shade name, e.g. yellow green (instead of chartreuse) to avoid confusion. However, there are one or two colours which are used constantly by china painters and which have become synonymous with a certain colour, for example American Beauty (deep damson pink) and Black Grape (deep purple black) and Ashes of Roses (grey-pink). The ones most used will be covered in the glossary at the end of the book.

★ ★ ★

The projects I have designed for you are varied both in technique and style and are intended as a guideline for the development of your own individual expertise and most have been designed for adaptation for both beginners and the more advanced student.

MATERIALS

CHINAGRAPH PENCIL A soft pencil suitable for drawing on china and glass; it will burn off during the firing process. Choose a fine one and not a thick black waxy one.

GRAPHITE PAPER A special light texture carbon paper for transferring designs to china. Difficult to obtain in the UK from stationers but china painting suppliers always stock it. It may be used many times.

FACE MASK For working with powdered colour whilst groundlaying.

6IN TILE For mixing colours on.

PALETTE Mixed colours must be covered to avoid contamination by dust and lint: Ready made palettes are available but a biscuit tin with a lid is a good substitute, with a piece of glass to fit the bottom.

PALETTE KNIFE For mixing colours with oils, a narrow flexible one is best.

6IN SQUARE PURE SILK Used to make a pad with a ball of cotton wool, this is for padding painted-on colour to obtain a smooth background.

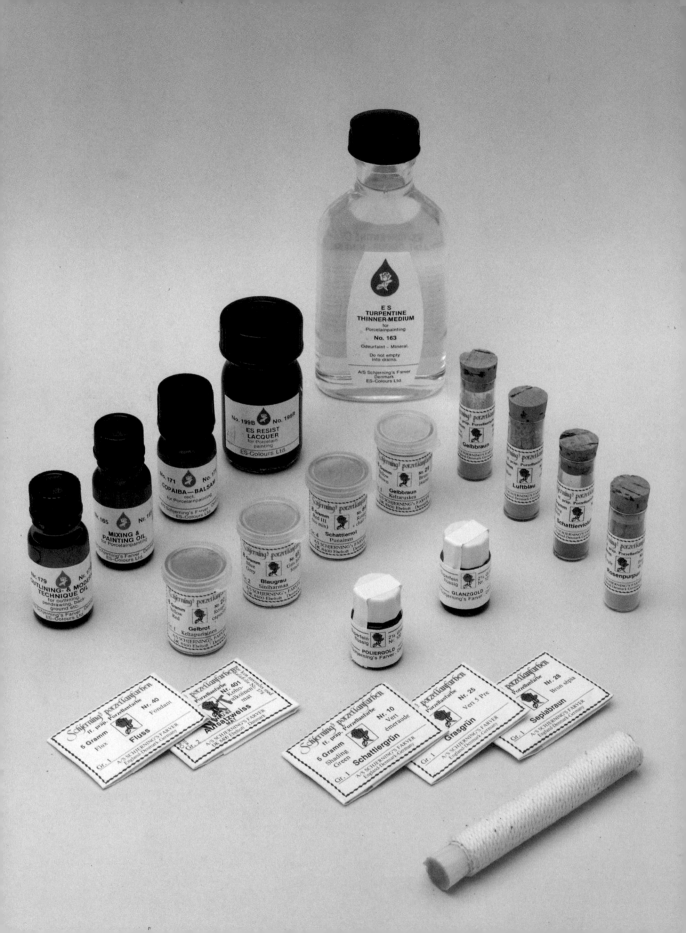

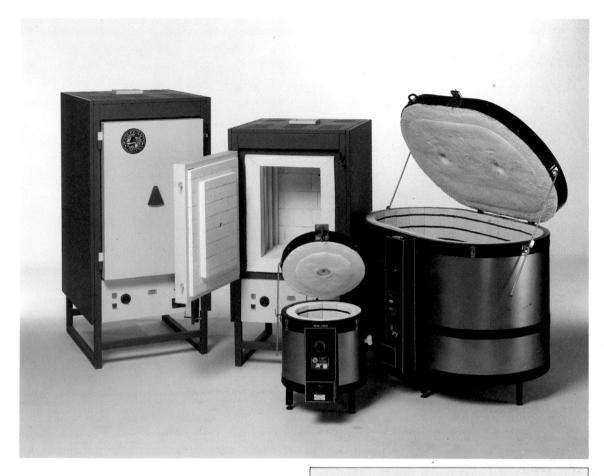

A selection of the commercial range of kilns available.

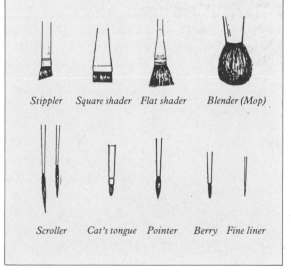

Stippler	Square shader	Flat shader	Blender (Mop)

Scroller	Cat's tongue	Pointer	Berry	Fine liner

*A selection of materials
necessary for china painting.*

COTTON WOOL Make into small balls and cover with two layers of silk to make a pad.

PAPER TOWELS Lint-free – used for cleaning brushes etc.

WET AND DRY SANDPAPER After firing, your china may be a little rough, very gently rub the china with a piece of fine sandpaper (not hard enough to scratch the glaze). To make an extra fine abrasive paper rub the two rough sides together.

WIPE OUT TOOL A stick with two little rubber pointed ends to wipe out highlights etc. You can also use the sharpened end of a brush stick.

TURPENTINE This *must* be the pure spirits of turps *not* the household variety. If allergic to this there are alternatives e.g. Limidex. Turps is used to clean your brushes and palette. If the used turps is poured into a screw-top container the sediment will settle on the bottom and the turps can be used indefinitely.

MEDIUMS & OILS (see the glossary for details of various oils) Oils are for mixing with the powdered paint so that it may be painted onto the shiny surface of the china. There are many oils available and it is a matter of personal choice as whichever one is used will burn away during the firing cycle, being simply a vehicle for getting the paint to stay on the china.

PEN OIL A special aniseed oil-based medium for mixing with colour to give a good consistent flow through a fine pen. (See glossary.)

ONGLAZE COLOURS Powdered colours (pre-mixed water-based ones are also available and are good for some types of work). These are made from metallic and mineral oxides, and hundreds of colours are available. The best quality ones are those with no gritty particles and which grind smoothly. If you buy any which are particularly gritty they can be sieved, but in my opinion they are best thrown away and substituted with a finer colour. I work with a palette of approximately 20 colours, but like all china painters have several dozen colours which I only use

from time to time and some which I can't live without! Reds mature at a lower temperature, approximately 750°C; pinks and purples which contain gold need a hot fire, 800-820°C; other colours approximately 780°C on bone chine, 800°C on porcelain.

KILN Pronounced 'kil'. Essential equipment: without the kiln firing the design painted onto the china would not be permanent. During the firing cycle the glaze melts and absorbs the colour. After the firing the design will have fused with the glaze and should look shiny; if it looks dull it has not been fired hot enough, and should be refired.

BRUSHES Your most important tool, and the one item you must not be tempted to economise on. Always buy the best you can afford and *look after them:* correct cleaning will repay you a thousandfold. I'm constantly appalled at the way students neglect their brushes after use. They should *always* be thoroughly cleaned in pure turps and then dried and conditioned with a fine smear of olive oil, re-shaped and put away in a dust-proof container. There is *no excuse* for dirty brushes. Before using, 'condition' the brush by dipping the point into your painting medium and gently wriggling the brush from side to side until it is moist all over with oil. Squeeze out the excess oil on the paper towel, keeping the brush in its true shape; you are then ready to paint. The hairs should all lie smooth with no 'strays' sticking out.

COTTON SMOCK OR OVERALL This is not so much to keep the paint off you as to keep the lint from your sweater or dress from settling on your (or someone else's) wet paint. I consider an overall essential and I will not allow students into my classroom without one.

SETTING OUT YOUR TABLE

The haphazard way some students set out their working area still surprises me; things are often spread at random on the table and much time is spent

looking for what they want. Worse still is when what they want is still at the bottom of their bag and minutes have to be spent rummaging for it. The correct orderly setting out of your workspace should be first priority before commencing painting. Fortunately with our art you do not need an enormous amount of space – an area approximately 2½ feet square is adequate.

Good light is essential, preferably north facing, but this is not always possible. Cover your work area with a piece of polythene and then with a sheet of newspaper (I always buy sheets of pretty wrapping paper for this as it cheers me up on dull days!). A piece of cotton sheet is a good alternative, and will absorb any spills.

For a right-handed painter set out the area as follows (left hander reverse); leave the immediate area in front of you clear for colour mixing, etc. Place your mixed colours on a palette on your right side. A jar containing turps should be close to you, slightly to your right. A flat-bottomed container containing approximately ¾ in turps (not ¼ in and not 2 in turps); I've seen students using as little as ¼ in of turps which of course is always filthy and some students with as much as 4 in in the jar always with predictable results! The jar should be close enough for you not to have to stretch over to clean your brushes. Nothing inwardly annoys me more when teaching than for students to have their turps in little jars with the lid screwed firmly on whilst painting, and every time they clean their brush they have to unscrew the lid – grrrr. Turps is cheap and readily available so there is no need to be miserly with it.

Your painting medium should be placed in a little dish by the side of the turps; have a slightly curved container for this so the medium is kept in a little pool. If it is allowed to spread over a wide area it will collect lint and dust. A folded lint-free paper towel placed next to this will enable you to shape your brush as you go along. Place your brushes in their container immediately behind the turps and painting medium; don't scatter them all over the table. Get into the habit of laying out the work area in a

disciplined fashion and you will enjoy your work much more. A sloppy working area means sloppy painting.

It is a good idea to place a small mirror approx 9 in × 9 in a few feet in front of you on your table; this is not to admire yourself (as one of my customers thought!) but so that you can hold up your piece from time to time. You will be amazed how it shows up imperfections in balance of design, for example, and it will also show if you have too much colour in one spot.

After completing your painting transfer either to a kiln or to a dust-free place.

HOW TO BE A GOOD STUDENT

After you have selected your teacher, listen to what she says and don't talk when she is explaining things to the class in general – later you will have to ask her what she said, and hold up the class. Always arrive on time with your palette of colours mixed ready to start, on time means about 5 minutes before the class is due to start and not 30 minutes before. Always leave on time; try not to be guilty of saying to your teacher 'Can I just ask you this one thing before I go?' Bear in mind that she has to load up the kiln and generally tidy up before she can go home and will be there for at least 20 minutes after the last student has gone home and often for an hour after.

Lay out your table in an orderly manner and do not encroach on other students' working areas. Make sure you have everything on the table you will need if your teacher asks for something, so that you do not have to rummage in your bag for it: anticipate what you will need and have it on hand. Do not go around asking other students who are more advanced for their advice or help; that is what your teacher is there for. The other students are there to learn and not to teach. If you would like some tuition by another teacher, this is OK providing you inform your regular teacher what you are doing; if she is a good teacher she will not mind.

Never take materials to sell during class to other

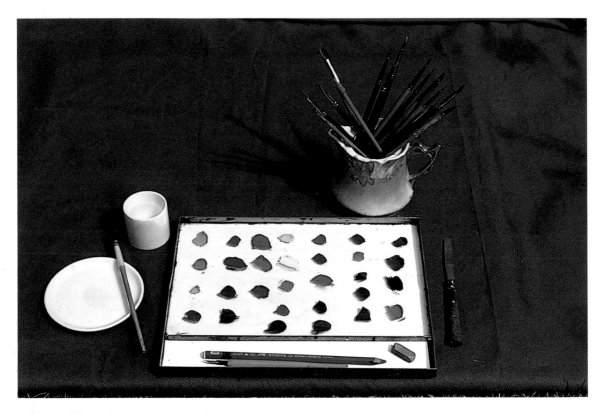

Setting out your painting area.

students without the prior consent of your teacher, as this is unforgivable. If you think your teacher is charging too much for materials you should bear in mind the following: she has probably had to drive several miles to obtain them using petrol and time, or she has had them sent by post which will have been expensive; she will also have spent several hours dividing the materials up into smaller quantities for you (do not forget the cost of the bottles either) and she must make some charge for her time. In addition, to obtain even a small discount she will have had to spend quite a lot of money which will be some time coming in. If you think you can buy the materials at a cheaper price she will not mind you getting them yourself but when you have added up the cost of everything you may get a surprise.

Last, but not least *listen* to what your teacher tells you and then carry it out to the best of your ability. If you are unsure of anything she has told you, ask her advice, and she will be glad to explain.

HOW TO BE A GOOD TEACHER

Share your knowledge generously with your students and do not be afraid to admit if you do not know how to do something, tell your student you will find out and tell her later. Do not 'hold back' anything because you are afraid of your students knowing too much, or you will end up with frustrated students who in the end go to another teacher for advice and this will do your reputation no good whatsoever. If necessary go on another more advanced tutor's course and learn what you do not know. None of us, no matter how long we have been teaching or painting can know it all; there are always new things to try and experiment with, and there is no better way than with

Chrysanthemums on white background sandwich plate.

trial and error. When experimenting (with your own pieces of course) do not be afraid to break the rules, you will get some pleasant surprises.

When starting new students make them aware of any special points you want to stress in your teaching, e.g. if you want them to wear overalls or use your own special mediums, etc. Always give them a structured syllabus to work from so that they will have an idea of what will be expected of them each term. Most of all *make teaching fun* — we all need a giggle occasionally!

POSTURE

There was a china painter who
Sat huddled up from 9 till 2
She had a pain — hiatus hernia
The doctor told her "that'll learn ya"
So stretch your legs from time to time
Rotate your neck & you'll be fine
Take this advice from little me
And you'll be painting at 93.

Think posture!!

I cannot stress enough the importance of good posture whilst painting: you should sit on a chair with a straight back and hold your work as high as possible, avoiding the necessity of dropping your head forward. Bad posture can cause all sorts of neck, back and hip pains, and can easily be avoided.

SELECTING YOUR CHINA

Your china and porcelain will have to withstand several exposures to the heat in the kiln so it is important to use only china which does not have any visible flaws. Avoid pieces with fine cracks, chips, spots which cannot be overpainted, boxes with badly fitting lids, vases and cups with uneven bases, etc. Examine the china carefully: if it has one or two little marks in the centre these can be fairly satisfactorily overpainted but if the flaws are on the edge you will not be able to overpaint with gold as this will only accentuate the flaws. It is up to you to examine the piece before buying and if it breaks in the kiln it is too bad, and is neither the fault of the seller nor the person doing the firing.

China or porcelain

When I started painting in Australia in 1969 only porcelain was available to paint and so for five years I worked on nothing else and was always delighted with the results. On my return to the UK I found a very limited supply of bone china and couldn't wait to try it. I was delighted with that also.

Outside the UK bone china is often treated as an unknown quantity, to be regarded with suspicion in the belief that it doesn't fire well; this is not true, it fires beautifully and unlike porcelain it has a marvellous glaze after firing. It does need a slightly lower firing temperature but I fire both types of ware together, putting the bone china in the coolest part of my kiln and the porcelain in the hottest part, and rarely get a failure. Occasionally one or two little dark spots will appear due to an inconsistency in the glost firing but often these can be painted over with no ill effects. The onglaze colours are more readily accepted by the glaze on bone china, hence the lovely gloss. Bone china is always pure white, porcelain is almost always slightly off-white.

One word of caution with bone china, however: do not let any pieces touch in the kiln as they will invariably fuse together, whereas pieces of porcelain can be happily stacked on top of each other with no problems. Sometimes you will experience a dark rim on the underside of a plate or other rimmed piece of bone china — this can be avoided by placing the piece on the unglazed side of a tile. I fire all my bone china thimbles this way. Fire bone china between 760-780°C and porcelain 780-850°C. Holding the

kiln on 'soak' for 30 minutes results in a gorgeous glaze on the pieces.

FIRING

Firing the pieces in the kiln is the final step in china painting and the culmination of all your hard work in the preceding stages. It is still a thrill for me to open the kiln after firing, and the only thing guaranteed to get me up early in the morning! There is no mystery surrounding the kiln providing the safety points are adhered to.

Firing is a simple procedure but a little daunting at first. The manufacturer's instructions are very clear and concise and if you follow them you will have no trouble, but be warned that the kiln glows a bright orange colour inside whilst reaching the high temperature; nobody told me this and I was frightened to see it the first time and thought something had gone wrong! The porcelain looks almost transparent at this stage (for those who don't know, there is a little spy hole in the side of the kiln to look through).

Kilns are made to the highest safety standard and little can go wrong with them. When choosing a kiln make sure it is of a size suitable for you; it needs to be big enough to fire a large plate lying flat and a teapot or vase upright. With careful stacking a lot of pieces can be fitted into a relatively small space; quite a lot of small pieces will fit around the large plates and by careful placing of the kiln furniture you will soon learn to get the most from your kiln. I have found some of the half-size shelves (or bats) very useful.

It is important when firing to leave the air vent (or bung) open long enough to allow the noxious gases to escape; if the kiln is sealed immediately it will affect the final appearance of the pieces, which will look discoloured. This applies particularly when firing lustres or gold and silver. I always leave the bung out till the kiln reaches 400°C, and if I am firing a lot of gold etc I leave it out till it reaches 500°C. Not allowing the gases to escape also damages the elements.

The kiln must be situated at least 12 in from the wall and in a position where adequate ventilation is available as the fumes are toxic and will make you ill if you breathe them in. You must never work in the room whilst the kiln is firing.

Unless I'm firing something really special like a very large vase, I have my kiln set at 'high' most of the time; rarely do I set it at 'low' and then turn to medium or high. I leave it set on 80 per cent all the time, place the pieces inside and just switch on and leave it alone except to close the air vent at 400°C. In eighteen years of painting I have only ever had seven pieces break in the kiln so I must be doing something right, mustn't I? I see no point in constantly adjusting the setting on the kiln unless I'm doing something really special, as it seems to make hard work out of a simple operation.

Opening the kiln is also a simple operation. It is not necessary to wait till it is completely cold before opening; I open mine about an inch at 400°C very gently and then allow it to cool for another hour before opening completely. This of course only after switching the power off: *never* open the kiln before you switch off the power point. The hot air escaping from the kiln is stronger than cold air which could enter it, so there is little risk of breakages.

Your kiln will need to be brushed out from time to time, as tiny particles will become loosened from the fire bricks and settle onto your china giving it a rough feel. The soft brush attachment on your vacuum will be perfect for this. If you have small children a safety lock for the door is essential.

A kiln sitter or automatic pyrometer takes the guesswork out of firing – alternatively, pyrometric cones can be used and watched through the spy hole until they bend, and then you have to switch off the kiln manually. This can be a bit of a nuisance as you have to be on hand all the time to watch it, but a very accurate firing can be obtained. A kiln sitter is not expensive and has an automatic device which will switch the kiln off when the required temperature is reached. It has to be used in conjunction with cones but does not have to be watched as the cone, when it

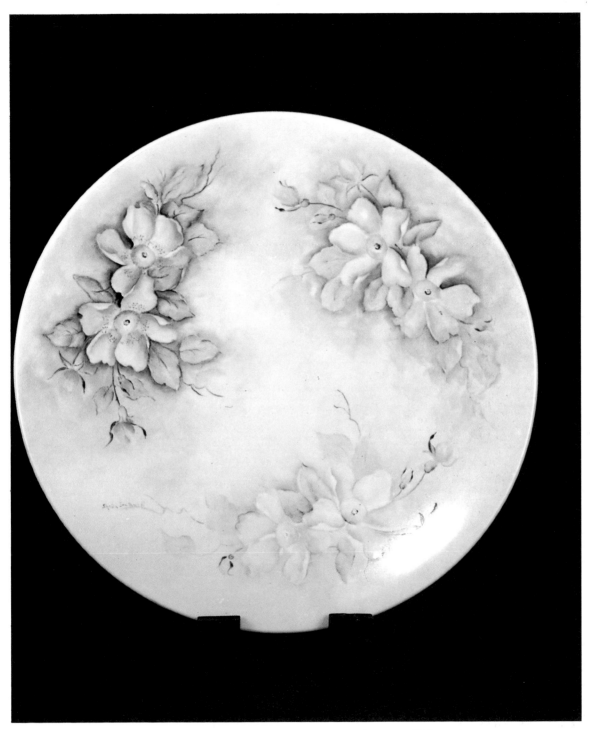

Loading the kiln. Plate showing three stages of firing.

23

melts, knocks a little lever which switches the power off. An automatic pyrometer is completely trustworthy and after setting the temperature you require on the dial you can leave it to switch itself off on completion of firing cycle.

Underfiring

This means that the kiln has not been fired hot enough and the resulting pieces will look dull in colour and will feel rough to the touch where the enamels have not 'sunk under' the glaze. Underfiring is easily rectified, just re-fire at the correct temperature.

I have seen more examples of this than any other firing fault. If you are paying someone to fire your pieces for you and they keep coming back dull and underfired, take the piece back and ask if you can have it fired at a higher temperature or take it to someone more qualified to fire it. Potters will often be guilty of this fault if they are firing your pieces, and you must state the temperature you require the pieces to be fired at. Your pieces should be shiny, with the colours well and truly fused with the glaze. It costs only pennies to fire the kiln a few degrees higher, and bear in mind that if the pieces are to be used to eat from it can be dangerous if the onglaze enamels are not protected by a layer of glaze, as the colour will eventually come off.

Overfiring

This means the kiln was too hot and the colours will be slightly distorted. Just re-paint and re-fire and the piece will be all right. Gold and silver and lustre are ugly when overfired and once overfired little can be done to rectify them. With overfired lustres you can try padding a little bright gold over with a small sponge which sometimes looks attractive. Gold if overfired has a crackled appearance, but most colours come to no harm with a few extra degrees in the kiln.

MIXING THE COLOURS

The powdered colours are ground with an oil-based medium to the consistency of toothpaste with a palette knife until they feel smooth, with no trace of sediment or grit. The mixed paint should cling to the knife when turned upside down: if the mix is too runny add more colour. If the paint is applied too thickly to the china blistering will occur during firing, ruining the piece.

With the fine art of china painting the technique is to paint and fire several times to obtain the necessary effect and not to apply the paint too thickly or too thinly – only experience will teach you the right balance. The paint must never be applied so thick as to destroy the translucency of the china. If you like ladling on the colours you may do better with oil painting, as the idea is to build up the depth of colour, gradually shading as you go along and firing in between. Of course there are no hard and fast rules for this but on average I would say three fires for a straightforward floral design or landscape, and for more complex designs such as portraits, six times is quite common. Complicated pieces with groundlaying and enamels often require many more firings. It is difficult if you do not have your own kiln, I know, but it is better to put on too little colour than too much as more can always be added later.

Commence painting by dipping the end of your brush into the painting medium first and then into your pile of coloured paint, and get into the habit of trying the colour on a tile before brushing straight onto the piece you are painting as this enables you to see exactly the colour you have on the brush. An open medium (see glossary) enables you to work for several hours more on the same piece than one which dries too quickly. Apply the brush onto the china where you want the colour, keeping it as smooth as possible, perhaps using a blender to stroke the paint smooth at this stage.

The most difficult colours to work with are the gold colours (pinks, rubies, purples) and if too much colour is applied it will be difficult to 'move about' (or as one of my students calls it 'shovel it about'). You will get little pile-ups of paint difficult to smooth out, so only the merest trace of these colours should be

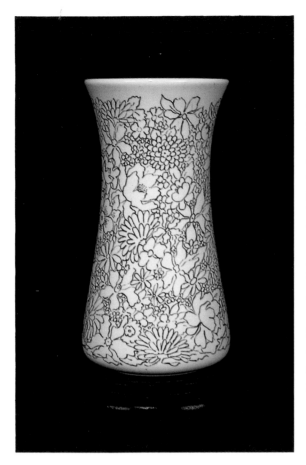

Vase showing all-over penwork before colour is added (similar to project on 'all-over flowers').

the colour more easily. Practise painting several colours and then blending them together so that no harsh lines show. This is done with a technique called 'filtering' using very light strokes. Moving the brush in different directions, the paint is 'fanned' rather than brushed, if the strokes are light enough. Another method is to use a large blending brush or mop to blend the colours together, and as an alternative you can also use a silk pad, but you should learn to do it with a brush first. Don't be put off – it took me months struggling to learn how to paint a good background until I realised I was using the wrong brush!

Highlights are made not by painting with white paint but by wiping out paint with a brush which has been cleaned with turps and wiped dry. Shadows under the highlights can be added on the next fire. 'Wipe out designs' are those where a background has been brushed on and the resulting design is cleaned out of the wet background colour; many lovely effects can be worked in this way, and the technique is used for painting white flowers.

PENWORK

Working on china with a fine pen is not difficult and can be enjoyed by a complete beginner, providing the basics are adhered to. The most important part is getting the pen medium satisfactorily mixed and using the correct nib. Special aniseed-based pen oils are available and are the most satisfactory to use; these can be obtained ready mixed or you may make your own.

Having selected your mixed colour, add aniseed oil to make an 'inky' consistency, in which you should be able to write your name without re-dipping your pen when it is correctly mixed. The colour should be nice and clear, with no 'fuzzy' edges. If you are getting a frayed edge to the lettering you have too much oil, while if the pen will not write you need more oil. It will be a case of trial and error at first but you will eventually get the mix right.

Always make sure the pen is perfectly clean before

applied on the first fire – more can then subsequently be applied on each extra firing.

Practising the main brush strokes cannot be stressed enough and beginners should not be discouraged because they cannot do as well as other more experienced students – practice makes perfect. There is no substitute for practice and one hour each day is better than six hours each week.

Painting a background

Not easy at first, but the correct brush works wonders. A ½ inch flat shader is a good size to start with and a little more oil in the brush helps to spread

Brush strokes

No.4 pointer

No.2 pointer

½" Flat shader

⅝" Square shader

Stippler

Putting the strokes together

Wipe-out technique

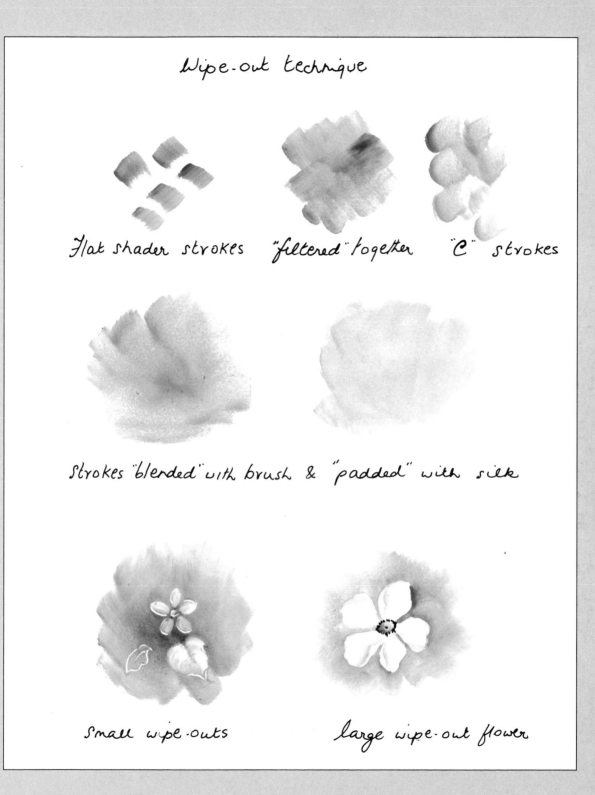

Flat shader strokes "filtered" together "C" strokes

Strokes "blended" with brush & "padded" with silk

Small wipe-outs large wipe-out flower

you start to write, and the nib is not damaged. Some people prefer a mixture which dries quickly (this anis mix does not dry until fired) and for this you can make a mixture with icing sugar and water, very syrupy, and mix the powdered colour with this, then dilute it with water to the correct consistency. Another way is to mix your colour with fat oil and then dilute with turps, which also dries quickly, and you can paint over it almost straight away.

Personally I always use the commercially purchased pen oil medium as it works beautifully every time, the only disadvantage being that it does not dry till fired so unless you are very careful you cannot paint over it straight away. I mix up little pots of different colours ready to use, e.g. black, grey, green etc (the ones I use most).

Use a different pen for sugar-based pen mediums and the oil-based ones, because if the sugary mixture is not cleaned thoroughly off the nib, it will not write with the oil mix, as the two are incompatible.

LUSTRES

The word lustre comes from the word *lustro* 'to shine', and its use originated in the East where it was used extensively by potters of the fifteenth and sixteenth century. During the early nineteenth century it became popular with British potters for use on earthenware pottery, which was made relatively cheaply. Often a wax resist was used to seal off areas to be decorated with other mediums or to form intricate patterns which after firing would show up white under the lustre background. Items completely covered in lustre took on the appearance of expensive precious metallic pieces.

Lustreware retained its popularity for the greater part of the nineteenth century in England and was the favourite technique of William de Morgan, many of whose fine examples are found in musems all over the world. Fairy-lustre was also very popular at the turn of the century where pieces, often large bone china bowls, were decorated with scenes depicting a fantastic fairyland which were then decorated with lustres and gold. Some of the best were made at the Wedgwood factory and painted by Daisy Makeig-Jones.

Lustres are made from metallic oxides suspended in liquid, the most expensive ones containing precious metals (pinks, rubies). The lustres come bottled in a liquid consistency which is dark brown when applied to the china, but during the firing a metamorphosis takes place and on being removed from the kiln the pieces have a lovely iridescence, the liquid having burned away, leaving a coating of precious metal. Unlike the enamel colours the lustre is not absorbed into the glaze but 'sits on top of it', and this accounts for the fact that with wear and tear the lustre will eventually rub off the china leaving little areas of the original white china showing through the lustre, as is evident with antique lustre ware.

To apply the lustre use a soft nylon brush as this will not shed hairs and spoil the effect; it is also very important to wear a lint-free overall as you will be amazed how clothing fibres can ruin a lustre piece where they have settled whilst painting. Ideally you should use a different brush for each colour as one will contaminate the other and spoil the effect after firing. If the lustre is applied with a swirling motion it will have a more iridescent effect. It will need two applications firing between each as the first coat will invariably have a patchy appearance. Different colours can be applied over each other after firing, often with dramatic effects, and a final coat of mother of pearl will enhance this further.

Lustres need to be fired at approximately 760°C. If overfired they will take on a frosted appearance which cannot be eradicated, if applied too thickly they can rub off or have a powdered look. Fingers should be kept off the cleaned china before firing as these can mar the effect. Always work in a well-ventilated area as lustres do not smell very nice and give off noxious gases whilst firing. The air vent should be left out of the kiln for a longer period of time when firing, or your finished pieces will have a dull appearance.

The colours will thicken with age and there are special thinners sold for the purpose of thinning these

– *never* thin with turps. Keep each one well labelled as all colours look the same in their bottles. If you want to mask off an area not to be painted with the lustre, use a lustre resist and peel off after you have used the lustre, *before* firing. If firing lustres with other painted pieces leave the air vent out for a longer period as above or your colours will look dull. Any area of unwanted fired lustre can be removed with a gold eraser.

There is a marbled lustre available which gives some interesting effects.

RAISED PASTE & RAISED ENAMEL

These are two completely different things and china painters are often confused. They are both used to add another dimension to your work and are made to stand out in relief from the body of the china and porcelain. A good way of remembering which is which is to bear in mind that raised paste powder is yellow and is used with gold, while raised enamel powder is white and used alone or with coloured enamels, and to say to yourself 'yellow for gold and white for white', that is how I remembered at first. They are both often called relief paste or relief enamel.

Special relief oils are available for use with these powders and give marvellous results if correctly mixed. The same oil is used for both, and thinned with water, and the brush used is cleaned with water not turps. Alternatively you can mix with fat oil and thin with turps to the correct consistency. It is also possible to purchase raised paste and enamels ready mixed in small jars.

RAISED ENAMEL

Mix the white powder with sufficient relief oil to make a crumbly texture and then thin with water till the enamel is like thick cream; this is then applied to your design using a fine pointed brush. You should practise until you can make little scrolls and dots with nice clean edges. If the edges are fuzzy you must wipe it all off and start again; nothing is lovelier than well applied enamel, but nothing is uglier than badly applied enamel. Practice makes perfect, and there are no shortcuts to this one.

If you would like coloured scrolls you can mix just a little of your onglaze colour with the prepared enamel, but remember that it will fire darker than it looks. Bright gold can be applied over the raised enamel after firing. Fire at 760°C. The enamel will flow on to the china better if it is picked up in small globules on the brush and then 'pulled' into the desired shape on the china.

The enamel should be allowed to dry for several hours before firing. If after firing it has blistered you have used too much oil, and little can be done to rectify this save to apply more enamel and re-fire. After firing do not rub your fingers over the raised work as this is often sharp and may cut your fingers.

RAISED PASTE

This is reserved for use with burnishing gold and is hardly ever used for anything else. It is mixed and applied in exactly the same way as the raised enamel, bearing in mind that it is to be covered with burnishing gold after firing. Bright gold is *never* used over raised paste and if you try the results will be disappointing, and you will waste your gold.

After firing the raised paste you must very carefully cover it with burnishing gold using a fine brush, making sure that you only cover the paste and not the surrounding china. There is no doubt that this, when well done, is the epitome of fine art. Only attempt this when you know you are proficient with raised enamels, or you will waste your precious expensive gold.

Fire the gilding at approximately 760°C and burnish after firing.

Raised paste/gilding should be the last process to be done on a piece. Try practising this technique by using raised enamels, then after firing paint over with a dark lustre and then examine the piece with a magnifying glass. Only when you can cover the

paste exactly are you ready to use the gilding procedure.

GOLD WORK

Gold work is the icing on the cake, the *coup de grace* on a well executed piece. Gold has been used for centuries as a measure of wealth and good taste and this is no less true of its use with porcelain. Gold is available in several forms but the two most commonly used ones are both in liquid form: burnishing, or roman gold and liquid bright gold. During the firing process the liquid burns away leaving only a coating of the precious metal on the china. Both types need two applications, firing between each.

On application the liquid bright gold is brown but on removal from the kiln it will be bright and very shiny and it is this which makes it unsuitable for use on large areas of china, as it looks cheap and vulgar; liquid bright gold is best reserved for plate rims and cup handles and other small areas to be decorated where it will look OK. It is not as durable as the burnishing gold.

If large areas are to be decorated with gold then the burnishing or roman gold is the one to use. Although it does cost a lot more to buy, it will undoubtedly add a 'touch of class' to your completed piece. This also comes in a liquid form but on application it is much darker, almost black with a very good quality gold, and it has a sediment which must be thoroughly shaken or stirred before use. The cost of this gold, often 22 carat, can be a deterrent, but there is no comparison between the two types and fortunately it can be purchased in small quantities e.g. 2 grams.

To economise on burnished gold it is usual to apply bright gold for the first firing and then burnishing gold on the second fire. On removal from the kiln the gold will be dull and needs to be 'burnished', either with a burnishing brush or with burnishing sand. The sand is used on a damp cloth and gently rubbed over the gold, which will then assume its beautiful patina. This is best done over a sheet of paper, as the sand then can be used again. If you use the burnishing brush, which consists of very fine fibres of glass, use it under a running tap, as the fibres are extremely painful if they get into the fingers or clothing, and it doesn't do the dog's paws any good either!

Do not touch the gold after removing from the kiln, particularly if it is still warm, as you will get finger marks which are difficult to remove. If your gold thickens *never* use turps to thin it: there is a special thinner for this purpose. This thinner is also used to clean the brushes used for gold. It is a good tip to keep a special brush for use with gold, and when not in use make a small hole (just big enough to hold the brush firmly) in the lid of a small jar, keeping a small amount of thinners in the bottom of the jar and suspending the brush, hairs down, over the thinners, to keep the brush in a moist condition ready to use again. The gold which settles to the bottom of the jar of thinners can be used again for first firings, etc.

If the gold is fired too hot it will crackle or separate. Fire it at approx 770°C. If applied too thinly it will assume a purple colour, just apply more and re-fire. Any unwanted gold smears after firing can be removed with a gold eraser sold for the purpose.

Gold (like the lustres) does not fuse with the glaze in the same way the enamels do and this is the reason why, with wear and tear, it will eventually rub off. However, it can be re-applied and fired in the usual way to good effect. If you try this on antique pieces which you have bought, you must be prepared for some disappointments for several reasons, e.g. if the piece has been invisibly repaired it will become separated in the heat of the kiln and will be in several pieces after firing. If there are any inconsistencies in the original glaze, be prepared for the piece to come out of the kiln covered with blisters or black spots. Only if the piece is completely undamaged and is good quality china or porcelain *and you are prepared*

Special techniques; marble lustre (top), antique gold metallic groundlay (left), copper-red (right) and a design using glass beads and liquid bright gold.

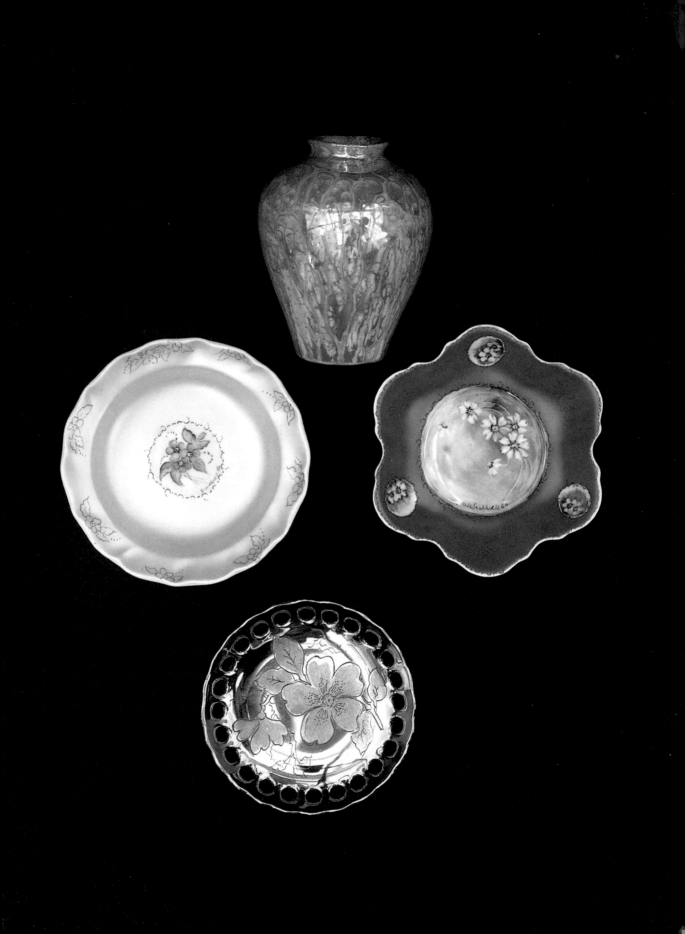

to take the risk should you re-gild and fire an antique piece.

SILVER AND PLATINUM

The use of these metals is similar to that of the gold, except that both are shiny on completion of firing. Platinum is preferable, as it does not tarnish as does the silver, and also has a softer appearance. I believe there is a burnishing silver available which I have not tried yet, though it sounds beautiful.

USING DECALS (TRANSFERS)

It's fun to use commercially bought decals occasionally and I believe that we should be familiar with all aspects of china decoration – even if we do not expect to use them very often we should know how they are used in the industry. The designs are printed onto specially prepared paper and are usually made with several designs to the sheet, which you can buy individually from your suppliers.

The decals are trimmed off the surplus paper around them and soaked for a few seconds in lukewarm water.

This makes them curl but they will flatten out after a little while and it is then possible to remove the decal from the paper backing. Do this carefully: if it is not sufficiently soaked you will tear the decal. Remove with your fingers and press gently onto the china to be decorated. Make sure the decal is correctly placed and then gently smooth with soft cloth or tissue to exclude any air bubbles which could blister during firing. When the transfer is completely dry fire at the usual temperature.

Making your own decals

This is a useful thing to know if you need to decorate the awkward inside of a mug with lettering etc, or if you have a design you wish to repeat several times. It is not really cheating as each one will be painted by yourself, but can save a lot of time when you are busy as they can be prepared in advance.

Using specially prepared Thermoflat or Unical paper, paint your design using a fat oil or fast drying medium – penwork is particularly effective if you are careful not to scratch the paper too much with the nib. When the design is completely dry (it must be thoroughly dry or the technique will not work) take a little covercoat (a plastic material specially for the job) and using either a stiff piece of cardboard or a large palette knife smooth a layer of covercoat over your dried design using *one stroke only* to completely cover the painted design. Allow several hours to dry and then use as described for the commercially bought decal.

The special Unical or Thermoflat paper has a plastic coating. The covercoat is usually either blue or white and will not affect the design as it will burn away in the kiln. Have fun with this.

SPECIAL EFFECTS

There are a few different techniques which I feel deserve a mention and whilst these may not be entirely your 'cup of tea' it is fun to experiment with something new occasionally. I believe we should, for our own education and interest, at least know and understand how these are done, so for this reason I am including one or two better known techniques which are easy to do and are particularly effective when combined with our more conventional styles of painting.

Gold flaking

This is a method of decoration where the glaze is removed from the china using small glass beads which are applied before firing and then removed from the piece after firing, leaving an uneven cracked effect on the unglazed china. This is then painted over with bright gold or lustre and fired again with pleasing results.

Mix copaiba balsam medium with flux, approximately half and half, and then paint it on to the area to be flaked, as smoothly as possible. Sprinkle the small glass beads over the painted area so that

they completely cover the medium, over a sheet of newspaper so that you can re-use the surplus beads. Shake off any loose beads and fire at approximately 780°C. Be careful if firing anything else at the same time that no loose beads become embedded in any other piece of china; it is better to place the beaded pieces on a separate shelf. Remove the beaded piece from the kiln and chip off all the beads. As you do this you will note that the glaze chips off also – be sure none of these chips fly into your eyes. It is advisable to wear spectacles when doing this as the chips are very sharp and it can be dangerous. All the beads must be removed and then this area painted with a fairly heavy layer of liquid bright gold and fired at 770°C.

This technique is particularly attractive when used on vases, boxes, and plate borders. The little glass beads come in several sizes and have a crazing effect. I prefer to use this technique on porcelain as the beads chip off more easily; on bone china, which has a softer glaze, the beads can be impossible to remove and if the piece is very thin, damage can result.

Turps and lustre repel

Many interesting and dramatic effects can be obtained using lustres and turps etc, and allowing them to run together whilst wet. Lavender and clove oils can also be used and often give prettier results.

Thoroughly clean the china with turps or alcohol, and dry. Paint a coat of lavender oil over the area to be decorated and then whilst still wet drop a few brushfuls of lustre onto the oil and allow it to run for a second or two, now turn the china into another position so the lustre runs in a different direction, and repeat this motion until you have the desired effect. Allow to dry and then fire at normal temperature. Gold can be used instead of the lustre for a different style of decoration.

This technique is practised by some fine porcelain artists who achieve the most beautiful effects by repeatedly applying and firing to produce fantastic landscapes. Lots of practice is needed here, but it is well worth the effort, and looks lovely on vases.

Metallic colours

These are a fairly new item on the china painting scene and are easy to use. They make a change from the platinum and gold effects and of course are much cheaper to use. The groundlaying technique described here is so easy that a beginner can do it with no trouble at all. Metallic colours make beautiful plate borders, or small areas to be used with Dresden work, and also look very good on small lidded boxes, giving a rich metallic appearance at a fraction of the cost of gold or silver. These metallic colours come in many shades including bronze, antique silver and gold, yellow gold, copper red etc.

METHOD Mask off with resist fluid the area not to be groundlaid and allow to dry thoroughly. Using your normal groundlaying oil, paint the chosen area and then pad with silk until smooth; you do not need to remove as much oil as with normal groundlaying as it is desirable to leave enough oil to 'grab' to metallic powder. Peel off the resist and using a large blender brush, apply the metallic powder to the padded area until it is completely covered, and if you can see any area which hasn't been sufficiently oiled and the colour is not adhering, wipe it all off and start again. Fire at 790°C. You will be delighted at the result – easy isn't it! For safety wear a face mask.

Groundlaying

Groundlaying is a method of obtaining a deep, opaque background colour in just one firing, which is often used with reserved panels decorated with flowers or scenes, etc. It is the most difficult technique in my opinion and will take plenty of practice to produce a good piece. As loose powdered paint is used in larger quantities *a face mask must be worn* for safety.

The powder should be sieved through two layers of nylon hose as there must be no small lumps of colour to ruin the effect. The area to be groundlaid is then painted with groundlaying oil (it helps to add a small quantity of the powdered colour, which will enable you to see where you have painted) making sure the complete area is covered. Then, using a silk pad, go

over the oiled area with a smooth padding movement until the oil is completely even, with only a small amount left on the china. The pad will make a 'sucking' sound when the area is sufficiently padded. Using a ball of cotton wool take up a large quantity of the sieved colour and gently apply it to the oiled area with a rolling motion: the loose cotton wool must not be allowed to come into contact with the oil, so there must be a good layer of powdered colour between the cotton wool and the china.

When the complete area is covered, gently remove the surplus colour, using a soft blending brush. The piece should now have the appearance of suede leather with no white patches of china showing through. The idea is to get an even layer of powder all over the piece — if you get more colour in one area than another it is no good and must be done again (I told you it was difficult!). Be extra careful when placing the pot in the kiln that you do not allow it to touch anything and don't scratch it with your finger nail. Fire very hot. On removal from the kiln the piece should have a beautiful dark, glossy, evenly-coloured background. If there are lighter areas showing through, you have not done it correctly.

Gold underlay

This is a safer alternative to acid etching and whilst it does not have quite the same effect it is nevertheless attractive and fun to do. The underlay is a powder mixed in the same way as the enamel colours and after firing it has a dull appearance. When the gold or silver is painted over it the underlay remains dull whilst the other area is shiny, which is very effective with designs of scrolls and reserved panels.

Lightly sketch on your design either with a pencil or with pen medium then go over this carefully with the mixed underlay keeping the strokes neat and clean; fire at 760°C. Using bright gold or silver paint the entire area and fire at 770°C: instant 'etching'.

Petit point

A very attractive decoration, particularly on bisque porcelain. If glazed porcelain is used it is better to give two coats of Ivory onglaze and fire them both first as it will give a better base on which to work. You will need a small piece of nylon net and a medium that dries quickly. Cover the china with the net pulled tightly over it, making sure the holes in the net look even. Matt paints are better with this technique and you can make matt colours by adding a little zinc oxide to the ordinary colours. Cover the net liberally with the colour which has been mixed with the fast drying medium and pad it as evenly as possible. Allow it to dry. Carefully remove the net and clean up any areas which need it with turps. Fire at 780°C. Sand after removal from the kiln. Now paint your design with regular china paints using little flowers such as baby roses and forget-me-nots.

Marbled lustres

These lustres are manufactured so that they marble, or separate, on application giving a most unusual and often attractive effect.

First clean the china till it is 'squeaky' clean and then keep your fingers off it as much as possible, as fingermarks can spoil the effect. Now using a soft brush apply the marbled lustre in smooth strokes: *do not* go over the same area twice or you will spoil the marbling effect. Now wait for a minute or two and the lustre will begin to separate into weird shapes, this is the marbling and you should not try to coax it into different shapes as it will shape itself. Once the lustre has been painted on it should be left alone. Fire at 770°C. Painting a coat of mother of pearl over it and firing again gives a glossy finish.

You can apply one layer of marbling lustre and fire and then apply another layer of different colour over the top with some pretty effects. It is possible to buy a liquid which can be painted over your regular lustre when it has been allowed to partly dry and this will cause it to marble, but I prefer the one with the separating agent already added to it when purchased.

I do hope you have enjoyed reading about some of the various styles of china painting and will proceed with some of the projects in the following pages.

Part 2
PROJECTS

'Where shall I begin please your majesty?' he asked.
'Begin at the beginning' the King said gravely 'and go on till you come
to the end.'

Lewis Carroll

I often use this design for complete beginners after they have mastered the initial brush strokes. It is simple yet effective, as the whole of the plate is used in the design, the little groups of florets giving an 'all over' airy effect which is pretty. The peony alone looks pretty on small dishes with a little gold round the edges, which gives it a professional appearance. Use a number 3 pointed shader for the little groups of strokes and the stems, and a number 5 with a rounded point for the flowers and leaves. The plate can be completed in one fire, or after firing you could outline the flower and leaves with gold and fire again.

Method

Sketch the peony and leaves on china and mark with pencil where the little florets are going to be. Do not get these too close together, and try to keep them evenly spaced. Using a light green, paint the leaves first, using each brush stroke to form the complete shape. Use as few strokes as possible and do not overwork. Paint the petals now, starting with the ones which are underneath and then gradually overlapping the top ones. Using black and a fine brush, paint the centres of the flowers to make them crisp and sharp and not muddy. Now carefully paint the little florets in whichever colour you choose; if you get one which looks uneven or lopsided, wipe it off and do it again. Fire 800°C.

Suggested shapes: plates, vases, oblong sandwich dishes.
Colours used: yellow-green, moss green, yellow-brown, black.

Beginner's Design

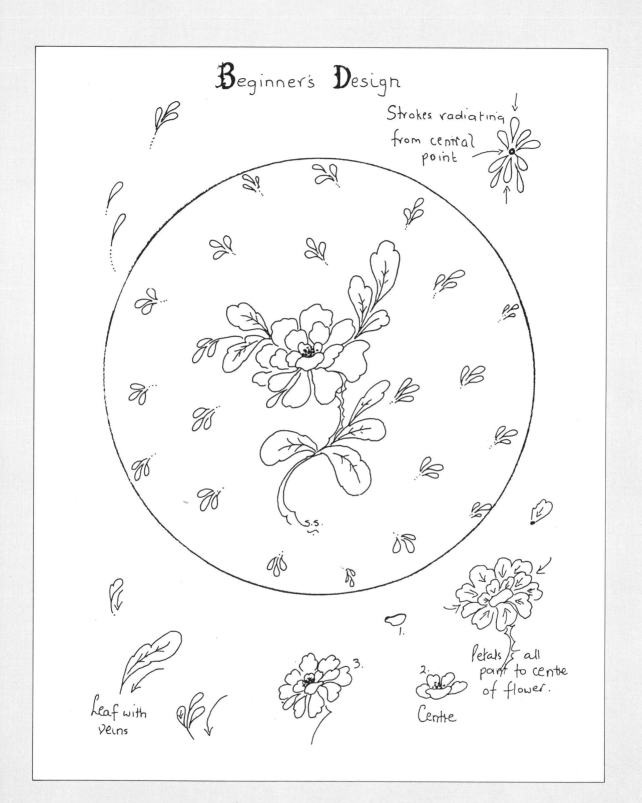

Strokes radiating from central point

Leaf with veins

1.

2.
Centre

3.

Petals all point to centre of flower.

S.S.

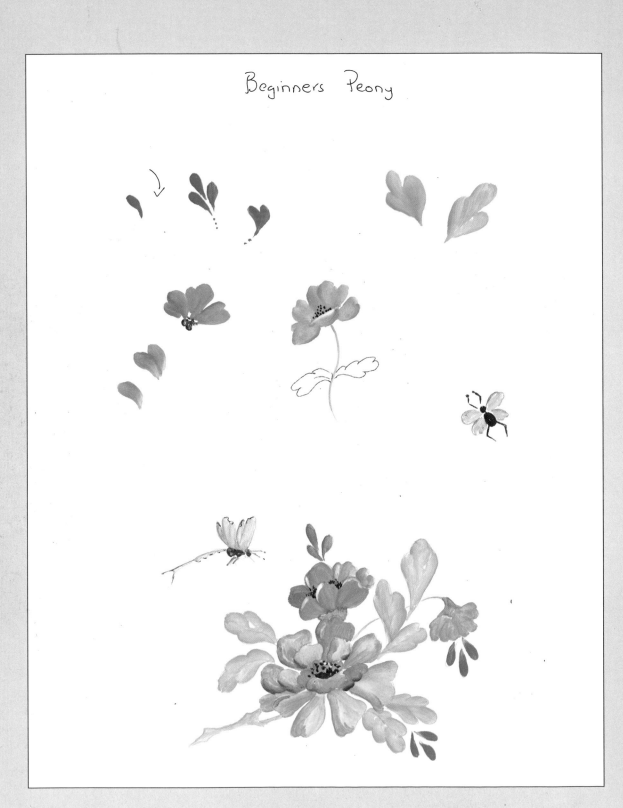

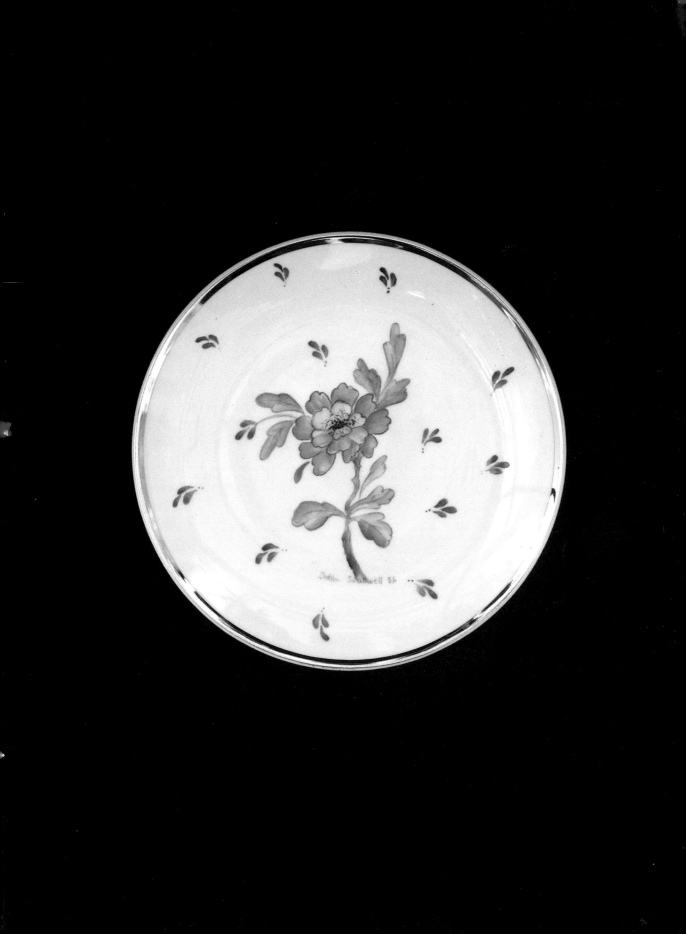

'I never knows the children − it's just six of one and half a dozen of the other.'

F. Marryat

One of the first things a beginner wants to paint is a little something for the children, so I have included three designs which are excellent for practising brush strokes, and which I have found to be popular: one for a small baby, one for a little boy and one for a girl (though the one for the little boy could also be used for a girl by making the hair longer). The baby design is nice for a birth gift showing the baby's name and birth date, as indicated. All three designs can be done in one fire if using a fast-drying pen medium, or if you prefer you can outline the design first and then fire and paint on second firing; whichever way you choose to do it, do make sure the subject has a pleasant face.

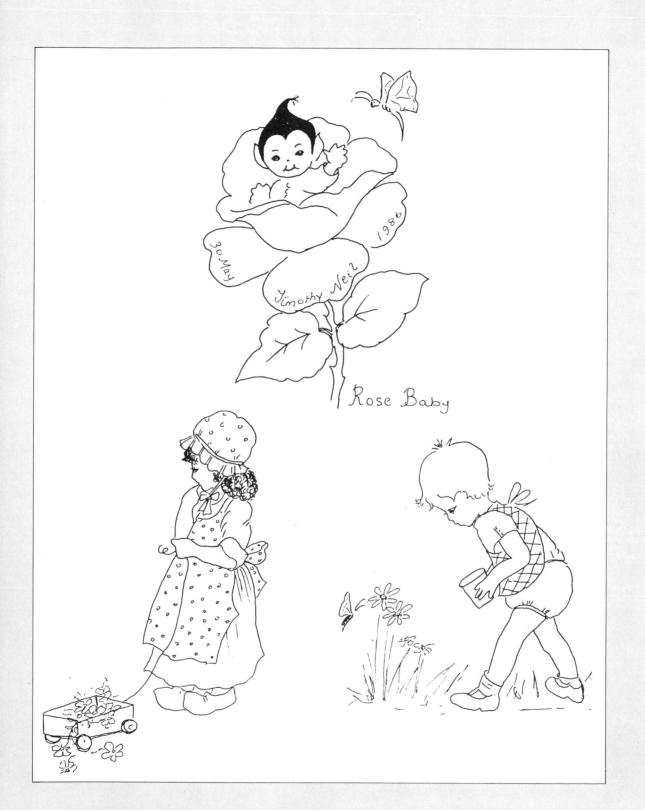

Rose Baby

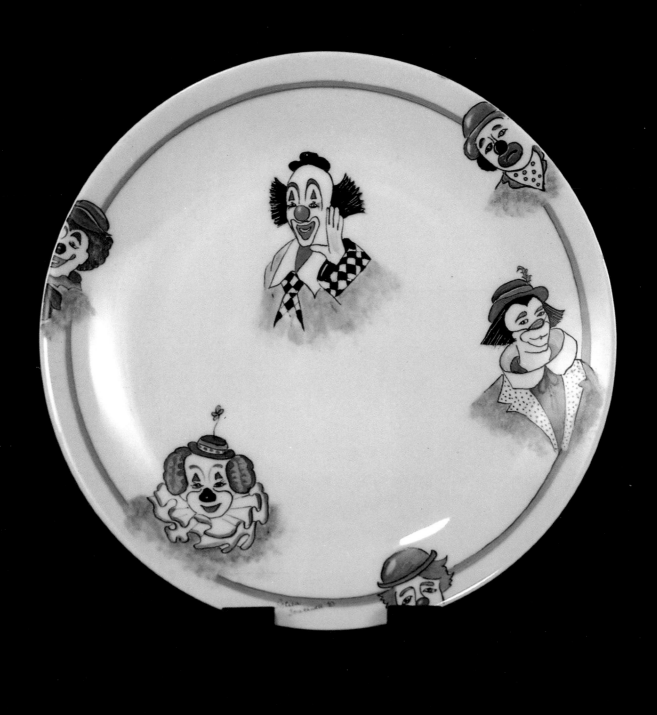

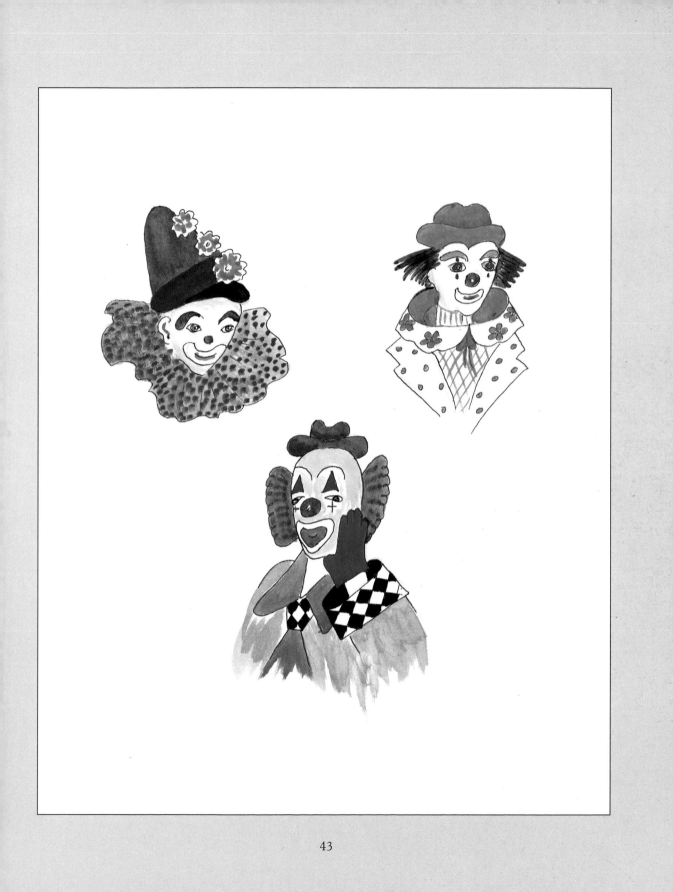

'Sport that wrinkled Care derides,
And Laughter holding both his sides.
Come, and trip it as ye go
On the light fantastic toe.'

Milton

Every so often it is relaxing to paint a 'fun' piece, something for our own amusement, and the following three designs are just this. The Clown plate will appeal to most people because it is bright and cheerful. The Theatrical plate was suggested by a circus design by Clarice Cliff which I saw in a museum: she had used a circus theme with the audience placed in sections around the edge of the plate. This adaptation was painted as a presentation for a friend in the theatre.

The idea for the Turban Girl came from an Indian cotton skirt I bought years ago. The faces on the skirt had always appealed to me so I decided to use them as a basis for a plate design; I used scrolls and raised enamel to fill the empty spaces on the plate. I keep a special file of such ideas filched from magazines, advertising hoardings and newspapers etc − perhaps just a small idea to start with, such as an attractively posed figure or a pretty 'shape' which could be used as a basis for a larger design, or even a logo which could be linked to a hobby or pastime. As a commercial project these designs will not have a large appeal but you will have endless fun in painting them just for yourself, and they usually make good conversation or exhibition pieces. I hope you enjoy painting them as much as I did. Have fun.

★　★　★　★　★

CLOWNS

3 Fires

The idea for this design came from a plate showing little Dutch dancing girls placed in a similar fashion. The plate looks equally jolly painted with only two colours or with lots of bright colours − the choice is yours. Black, scarlet and gold is a very attractive combination. It is possible to manage this design in one fire if you choose appropriate colours which fire well in one go. I did this one three times to obtain a really dark opaque black and bright scarlet.

1st Fire

Sketch the clowns on a plate and then using a fast-drying medium lightly outline the design, using black. Paint the clowns in bright colours making the black really dark. Fire at 800°C.

2nd Fire

Keeping the colours crisp and clean, go over the whole design. Fire at 800°C.

3rd Fire

Using a banding wheel paint the band around the plate. Fire at 800°C.

Design suitable for: plates, mugs, children's plaques, vases, etc.
Colours used: yellow-red, black, turquoise.

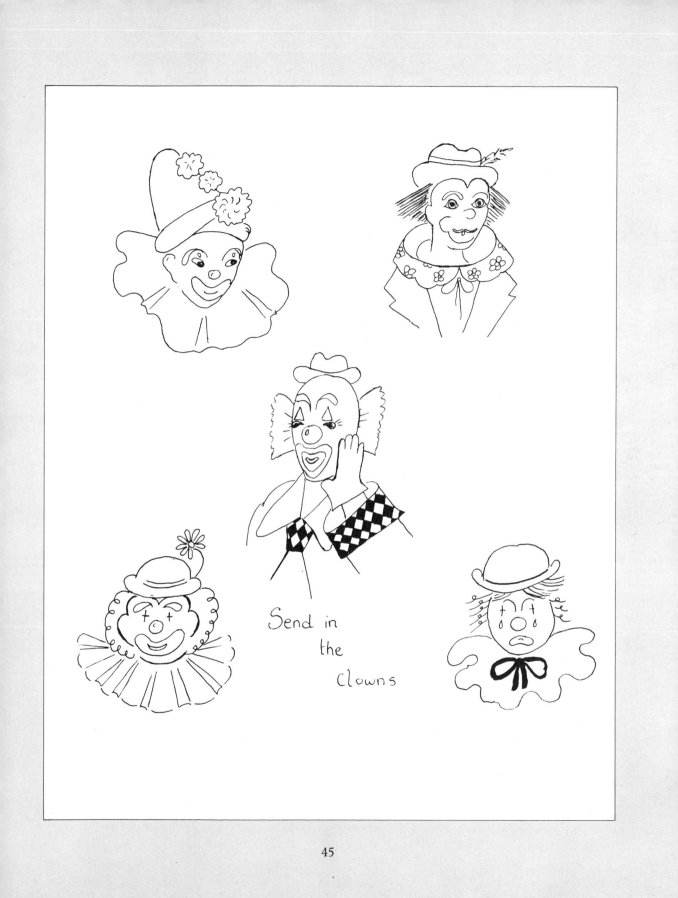

Send in
the
clowns

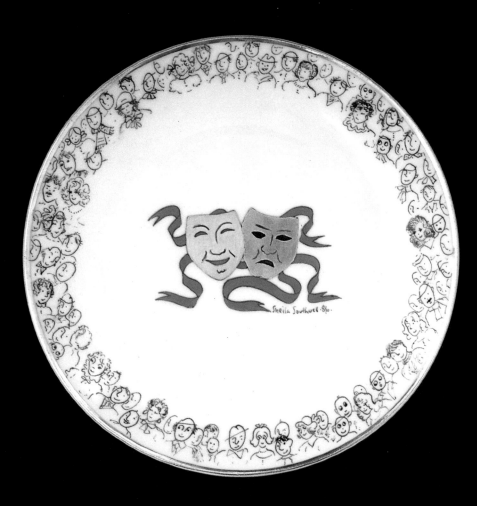

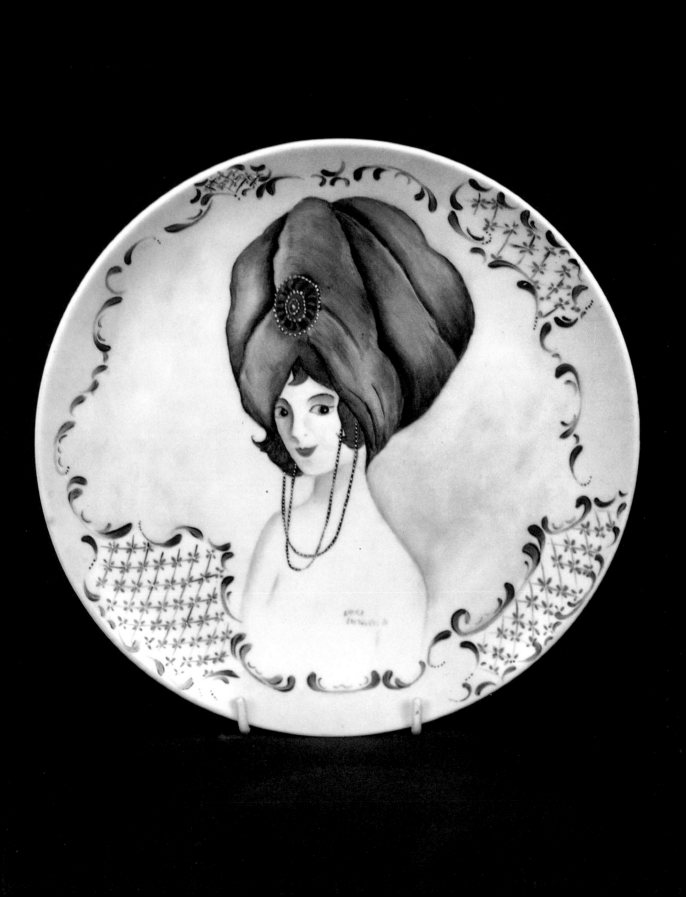

THEATRICAL PLATE

'All the World's a stage,
And all the men and women merely players;
They have their exits and their entrances;
And one man in his time plays many parts.'

<div align="right">

William Shakespeare

</div>

Being particularly interested in all aspects of the theatre, I had for years wanted to paint something in this vein. The idea for this plate was stimulated by a Clarice Cliff design which I saw in the Brighton Museum. I used the theatrical masques for the centre portion of the plate and the audience for the edge section − note the faces are all different. It takes a long time to do all the faces with a fine pen, so these are best done a few at a time, or you will find yourself repeating the same face. The most difficult part is painting the faces with different expressions, but it is great fun.

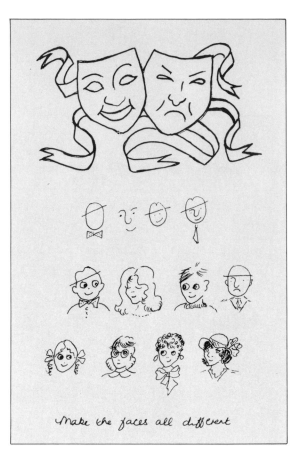

Make the faces all different

1st Fire

Sketch or trace the central masques and outline with a fast-drying pen medium. Sketch in part of the edge design. Fire at 780°C.

2nd Fire

Paint the face with bright gold first, leaving the silver one till the next fire. Paint the ribbon with bright scarlet, keeping the wet colour away from the gold. Paint the eyes and mouth on the 'sad' masque with black. Pen in some more people on the edge. Fire at 780°C.

3rd Fire

Apply a layer of burnished gold over the bright gold. Paint the ribbon with a second layer of scarlet. Complete the people round the edge of the plate. Fire at 760°C. Burnish the gold after firing.

4th Fire

Paint the eyes and mouth of the 'happy' masque with scarlet. Paint the 'sad' face with platinum. Fire at 760°C.

5th Fire

Give the 'sad' face another application of platinum, and finish off any scarlet on the garland. Apply a gold band around the edge of the plate. Fire at 760°C. Burnish the gold after firing. If the eyes and mouth etc. need outlining again, do it now and re-fire.

Design suitable for plates only.
Colours used: bright gold, burnishing gold, platinum, scarlet, black.
Variation on a theme: circuses, ballet, opera, music, etc.

TURBAN GIRL

'Our father Adam sat under the tree
and scratched with a stick in the mould;
And the first rude sketch that the world had seen was joy to his mighty
heart
Till the Devil whispered behind the leaves
"It's pretty, but is it Art?"!'

Kipling

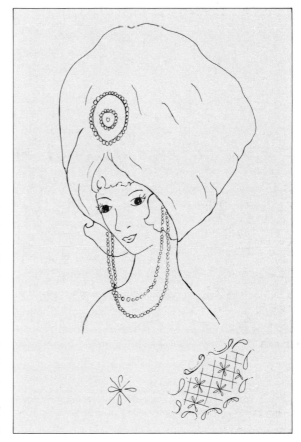

This is not a portrait and can be completed in two fires although I myself added a few extra touches and took three fires because I wanted gold and raised enamels. The design was adapted from an Indian skirt which had faces all around the hem: I wore out the skirt, but it seemed too pretty to throw away and I knew it would 'come in useful' some day!

1st Fire

Trace or sketch design onto the plate and outline the figure with fast-drying pen medium using light black grey; do not get it too dark. Paint the turban with green, keeping shading soft at this stage, and wipe out some highlights in the fabric. Paint a light wash of ivory and flesh pink over the face, maintaining the highlights on the forehead and nose and chin − it is not a portrait so little shading is needed. Paint a little pale pink on the lips. Establish the nose and eye keeping a highlight on the pupil. Paint the hair with soft brown. Using a pointed brush paint the scrolled border with green, then paint the latticed lines inside the scrolled border using a fine brush and green paint, and the little florets inside scrolls with scarlet making sure you have a clean brush. Fire at 780°C.

2nd Fire

Shade the turban with darker green, maintaining the highlights. Add a little more colour to the face and finish the eyes, then add a little shadow under the eyebrows. Paint the mouth in red-pink. Shade the area of the face in shadow with a little grey. Deepen the hair with dark brown. Paint the centre portion of jewel in turban with red-brown. Paint a wash of ivory and flesh over the shoulders. Filter a little colour over the background using yellow-brown, pink and ivory. Paint over the florets with scarlet. Paint a wash of yellow-green around the edge of the plate between the scrolled sections. Paint the turban strings with dark green.

3rd Fire

Paint the jewel in turban in bright gold, then using white enamel add little touches to the centre jewel, to the turban strings (forming little beads) and to the centres of scarlet florets. Fire at 760°C.

Design suitable for plates only.
Colours used: scarlet, leaf green, dark green, light brown, dark brown, grey, pink, flesh, yellow-brown, white enamel, bright gold, red-brown.

'A gift that's given, however small,
Will always bring much pleasure,
But made by one's own loving hand
Will be a joy to treasure.'
　　　　　　　　　S. Southwell

PINK ROSE 'SHAPED UP' WITH A PEN

1st Fire

Using soft pink paint the rose and wipe out highlights, filter pale green round the rose and fade colour out towards edges of dish. Fire at 800°C.

2nd Fire

Using a very fine nib and black-grey pen medium outline the leaf shapes, sketch the stem and leaf veins. Filter blue-green around the design being careful not to disturb the pen lines, shade the leaves lightly with blue-green, shade the rose with more pink. Fire at 780°C.

DAISIES WITH WHITE ENAMEL

This is one of my favourite little pieces. Even though it is very simple to do, it is very effective if the right colours are used. I did it in one fire but you could add the enamel on the second fire if you prefer.

1st Fire

Where the main flowers are to go, filter the background using black and dark blue-green, gradually shading it out with a little lemon yellow. Do not take the colour right to the edge of dish because it needs to be clean to take the gold. Using a brush cleaned with turps and thoroughly dried, wipe out the little daisies starting with the centres. Paint the ones at the back first, pulling the petals well into the centre. Paint the centres with lemon yellow shaded with a little yellow-brown at the bottom. With a fine brush paint the dots around the centres with black; keep this part very clean and sharp, and if you get smudgy centres wipe off the whole design and start again.

If you prefer, you can fire the piece and add the centres and enamel on another fire, though it is possible to do it in one fire if you are careful. Using white enamel, apply a little to the petal edges. With your finger apply a border of bright gold to the edge of dish. Only do this all in one fire if you know you are proficient enough not to smudge the colours and enamel. Fire at 760°C.

THE POSY SHOP

This is done in two fires and was copied from an old dish bought in a junk shop for a few pence. It was badly chipped, but the design was exquisite.

1st Fire

Carefully sketch the shop but do not add the coloured pots of flowers at this stage. Using a fine brush paint the outline of the shop with light brown making sure all the lines are straight. Fire at 780°C.

2nd Fire

Lay a wash of yellow-brown over the building, keeping it fairly light. The canopy is painted in soft turquoise shaded with deep blue-green. The windows are painted in grey with some highlights wiped out of the panes. Now using a small brush paint in the flower pots with bright clear colours. Fire at 780°C.

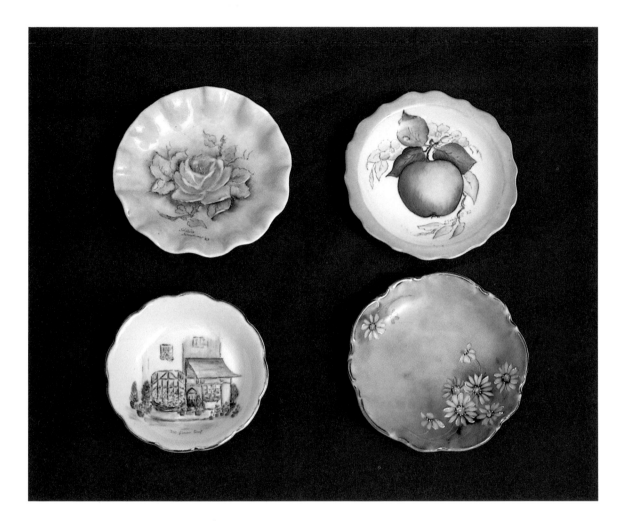

APPLE DISH

1st Fire

Sketch the apple and leaves only and paint the leaves using yellow-green and moss green to shade them. Paint the whole apple with yellow on the light side and yellow brown on the shadow side, maintaining a small area of white on the portion nearest you. Fire at 780°C.

2nd Fire

Using a very fine pen draw the dainty blossoms and give them the palest tint of pink with yellow centres, shaded with yellow-brown. Using the pen, draw in a few extra leaves and give them a wash of palest green. Shade the other leaves with darker green. Paint a wash of green on the yellow portion of the apple and a wash of yellow on the portion left white, which will be the lightest part. Shade the darkest part of apple with damson pink and yellow-red and blend the colours together with a fluffy brush so that no harsh edges show − still keeping the lightest area of fruit a pale yellow. Paint the seed end with dark brown and the stalk with light brown shaded with dark brown. Fire at 780°C. A touch of white enamel can be added to the apple blossom if you like, to make it look pretty.

Four small dish designs

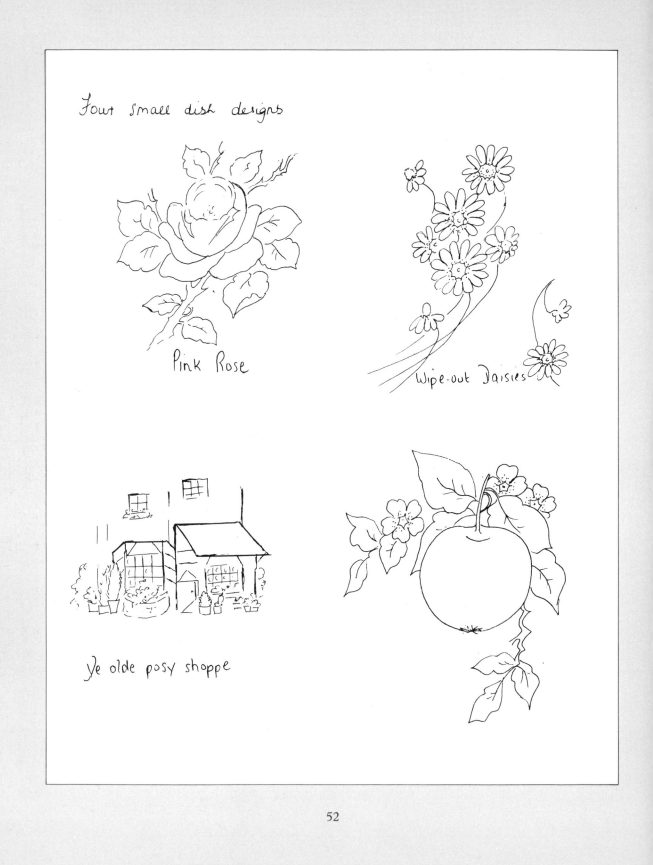

Pink Rose

Wipe-out Daisies

Ye olde posy shoppe

'A thing of beauty is a joy for ever:
Its loveliness increases; it will never
Pass into nothingness; but still will keep
A bower quiet for us, and a sleep
Full of sweet dreams, and health, and quiet breathing.'

Keats

Of all the things I paint I think I prefer doing the little lidded boxes most of all. What could be more lovely to receive than a little box showing the flower of the season – with a personal inscription printed inside the box to mark the occasion? *Never* paint a box and leave the inside plain: it is such a disappointment to open a box and to have no design inside. It is a nice extra little touch to paint a tiny flower inside the lid, too. Do not forget if painting a bone china box to remove the lid before firing or the two will fuse together and will be impossible to separate; porcelain boxes can be safely fired with their lids on, though.

WILD VIOLET BOX

1st Fire

Lightly sketch on the design and filter a wash of background colour around it using violet-blue, deep violet, yellow-green, and blue-green, keeping it darker just around the flowers. Paint a wash of pale blue violet over the flowers and yellow-green on the leaves. Fire at 800°C.

2nd Fire

Paint the underneath flower with deep violet and the other with violet-blue in parts only. Paint the centres with yellow, using dark green, to add the shadows to the leaves. Paint the flower and leaf veins using a fine brush. Paint the stems. Add any darker background where necessary. Paint the base of the box with

yellow-green and pad with silk. Paint a little flower inside the box and lid. Fire at 800°C.

Some flowers of the season with their Chinese origin			
	Flower	*Meaning*	*Accompanying design*
SPRING:	Peony	Plenty, strength	Bride and attendant, peacock
	Cherry Blossom	Youth, womanly beauty	Young people
	Narcissus	Good fortune	Fairies
	Willow	Charm, meekness	Swallow
	Camellia	Beauty, good health	Dragonflies
SUMMER:	Convolvulus	Love, marriage	Humming birds
	Lotus	Purity, fruitfulness	Duck
	Magnolia	Feminine beauty	Bees
	Aster	Charm	Butterflies
	Iris	Grace, affection	Bees
	Poppy	Rest, striking beauty	White bear
	Rose	Fragrance, prosperity	Bees, humming birds
AUTUMN:	Chrysanthemum	Joviality, ease	Dragon, crab
	Gardenia	Feminine grace, subtlety	Swifts
	Oleander	Beauty, grace	Birds, insects
WINTER:	Almond blossom	Womanly beauty	Court ladies
	Jasmine	Sweetness	Butterflies
	Fungi	Long life, immortality	

DARK GREEN GROUNDLAID BOX WITH RAISED ENAMEL

The reserved centre panel is masked out with masking fluid and allowed to dry thoroughly.

53

Little Boxes.

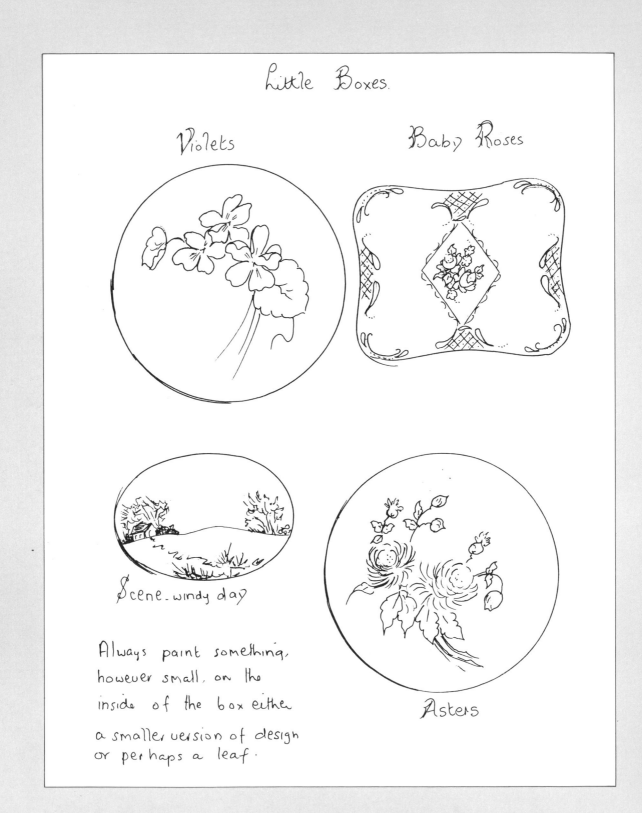

Violets

Baby Roses

Scene - windy day

Asters

Always paint something, however small, on the inside of the box either a smaller version of design or perhaps a leaf.

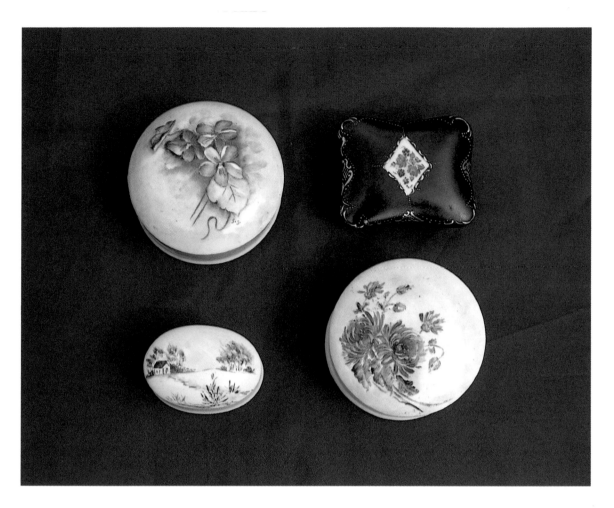

1st Fire

Dark green is groundlaid over the entire box (the masking fluid is removed after oiling and *before* adding the powdered colour) and fired at 850°C.

2nd Fire

Paint in the baby roses and other flowers and add the scrolls and dots with white raised enamel. Fire at 770°C.

YELLOW SCENIC BOX

This little oval box was completed in one fire. Paint the whole box with Albert yellow with a flat shader. The sky is painted with little strokes to indicate the fast moving clouds on a windy day. The scene is then painted with chocolate brown over the wet yellow paint using a fine brush. Inside the box is a windblown tree scene. Fire at 800°C.

ASTER BOX

This box was also painted in one fire. Brush pale yellow-brown, lemon and pale turquoise all over the box with a flat shader, keeping it fairly pale. The asters were painted over the wet background using a small pointed brush, and using the same strokes as I use for chrysanthemums − one stroke only for each petal, keeping the colours sharp. Fire at 800°C.

'To see a World in a Grain of Sand,
And a Heaven in a Wild Flower,
Hold Infinity in the palm of your hand,
And Eternity in an hour.'
William Blake

Weedkillers have eradicated poppies from cornfields, except around the edges of the fields, but in the UK the flowers still cover railway banks and waste areas with a blaze of colour from June to August each year. They also spring up on disturbed ground as they did in Flanders after the battle had finished in World War 1 and it is for this reason that poppies are sold for war charities on Remembrance Day each November. The common poppy is 1-2 feet high and has smooth globular fruits and bristles on the stem. The petals were once used to make a syrup and the seeds yield two grades of oil: an edible oil and a coarser grade of oil used by artists in mixing paints. Poppies come in various shades and petal sizes but the most popular variety with artists is the scarlet poppy.

1st Fire

Sketch the poppies and mushrooms onto the china. Paint the leaves with light grey-green. Wash a little yellow on the centre portion of each petal and then paint with yellow-red, and blend the two colours with a soft brush, keeping the yellow highlight on each one and pulling the petals towards the flower centre. Paint the centres with blue-green. Using ivory yellow, wash a little colour over the mushrooms and paint the undersides with pale grey. The poppy buds are painted with grey-green, and so are the stems. Apply bright gold to the edges of plate and fire at 780°C.

2nd Fire

With olive-green, filter a little background around the base of the design, gradually blending it into blue-green around the poppies and into pale blue at the top of the plate, softly tinting the rest of the plate with pale yellow, ivory and water green and pad lightly with silk. Clean off any background colour which has been painted over the flowers and mushrooms, making sure that all the design is now clear and clean. Add more yellow-red to the flowers, blending it into the yellow on the centre of petals. Shade the poppy leaves with blue-green and olive, maintaining some highlights. With deep blue-green, shade the poppy centres keeping a little light area. Paint mushrooms with yellow ochre, keeping an area of light on one side. Mix grey with ochre to shade the undersides. Fire at 780°C.

3rd Fire

Complete the shading where necessary on the flowers' leaves and mushrooms. Paint in the black pistils on the poppy centres and using a wipe-out tool make some little stamens around the centres and then with the end of the brush pull out some little lines all round the centres. When painting the black stamens, do not put them in a circle but paint them at random. With fine brush, paint in the stems, and whilst still wet take a very fine brush to form the little hairs characteristic to the poppy; do this also on the buds. Now deepen any background colour where necessary. Apply burnishing gold to the plate edges. Fire at 770°C and burnish gold after firing.

Variations: poppies can be painted on almost anything and lend themselves perfectly to Art Nouveau designs.
Colours used: bright Albert yellow, ivory, water green, moss green, olive, black, blue-green.

Poppies & Mushrooms.

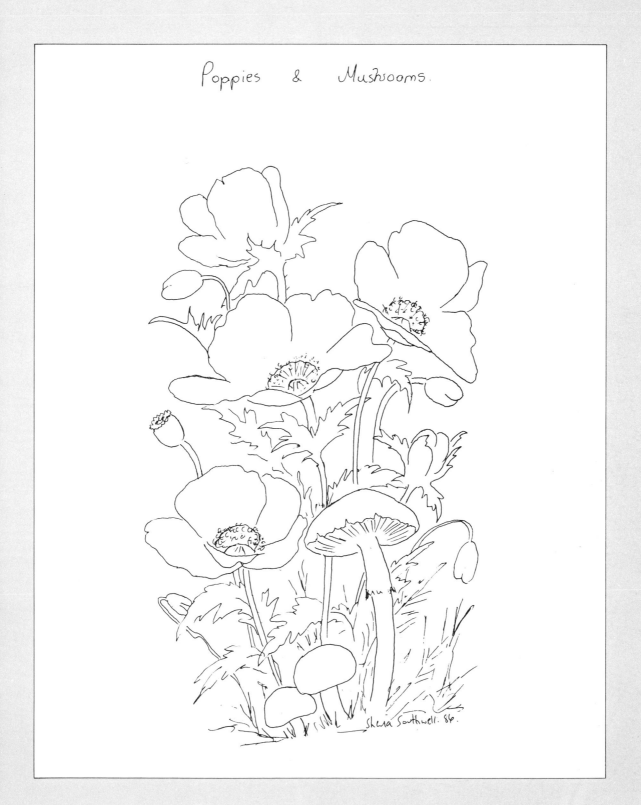

Sheila Southwell. 86.

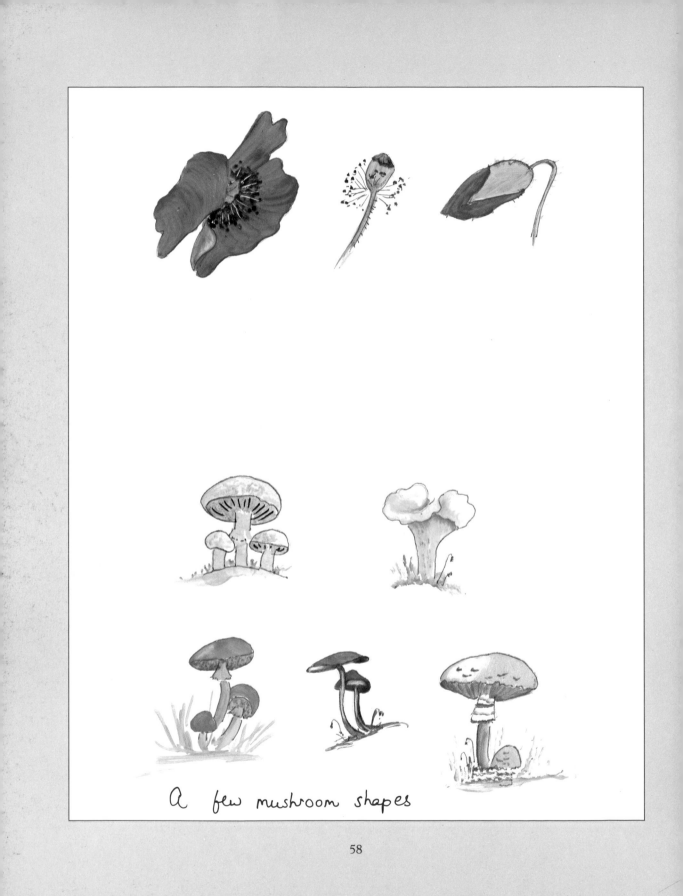

A few mushroom shapes

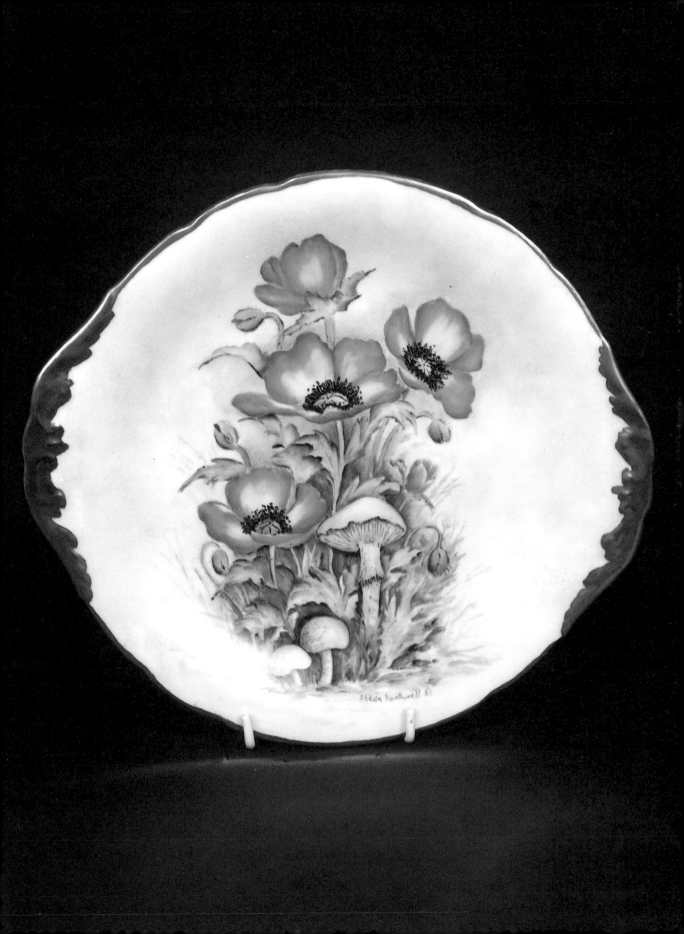

'I have plucked a flower in proof
Frail in earthly light forsooth
See invisible it lies
In this palm now veil thine eyes,
Quaff its fragrance.'
 Walter de la Mare

The freesia is a fragrant plant belonging to the iris family. It is a native of South Africa but is cultivated throughout the world. The flowers come in shades of pink, mauve, yellow and white and grow in spikes. The leaves are swordlike and the stems often bend at right angles near the top. They are not an easy subject to paint, as the stiff stems make designing difficult; however, like the iris, they look lovely painted on vases.

1st Fire

Lightly tint the plate with mauve, lemon, ivory and pink, and pad well with silk. Fire at 850°C.

2nd Fire

Sketch the design carefully on the china. This is one type of design where I trace in details, as there are so many buds and stems, and if not drawn correctly these tend to 'disappear'. A more disciplined style of painting is required here to achieve the detail. Using light shades of mauve, pink and yellow, paint the flowers pulling the colour deep down into the throat of the flower and making the trumpet area darker, as it is under the flower petals. Make the buds long and rounded at the top when painting, and wipe out any highlights. Apply a fine band of lilac to the edge of the plate using your finger.

3rd Fire

Add the leaves on this fire, using a medium shade of green so that the leaves go right behind the flowers. Keep a few highlights on one side of the leaf. Wash a little background colour over, using shades of blue-mauve and pink, keeping it very light. Shade the flower petals and add yellow to centres. Measure the area around the plate where the little groups of florets are to go; I use my finger to measure this. Paint the little design around the edge with blue-violet. Fire at 800°C.

4th Fire

Shade the leaves with blue-green and make one or two shadow leaves. Add some feathery strokes round the base of the flowers with green and blue. Using white enamel, paint some highlights here and there on the petals and make some little stamens in the centres using dots of enamel. Add enamel to the border design and make little dots all round the plate. Fire at 760°C.

Variations: vases, oblong sandwich dishes.
Colours: mauve, blue-violet, pink, lemon, yellow, white enamel.

Freesias

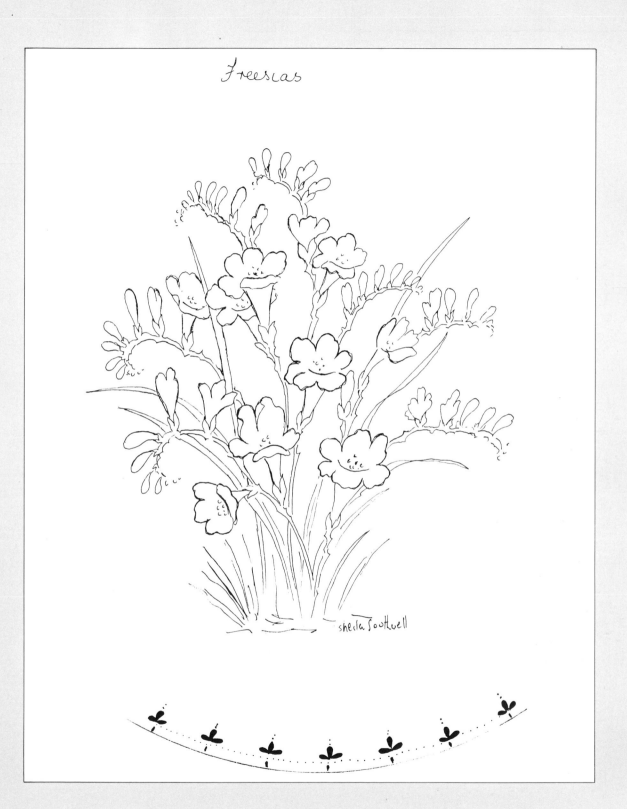

sheila Soothwell

Freesias

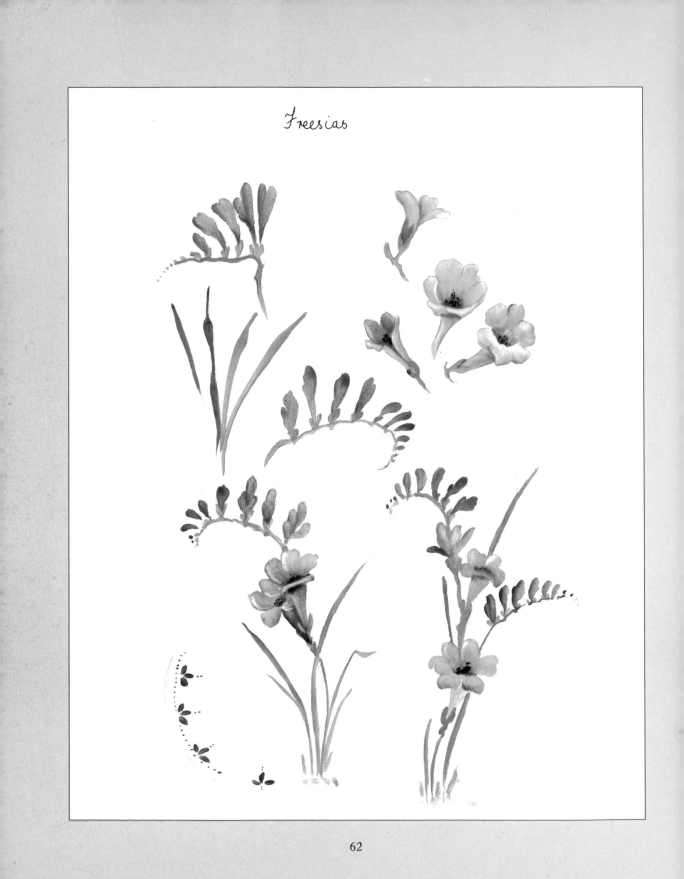

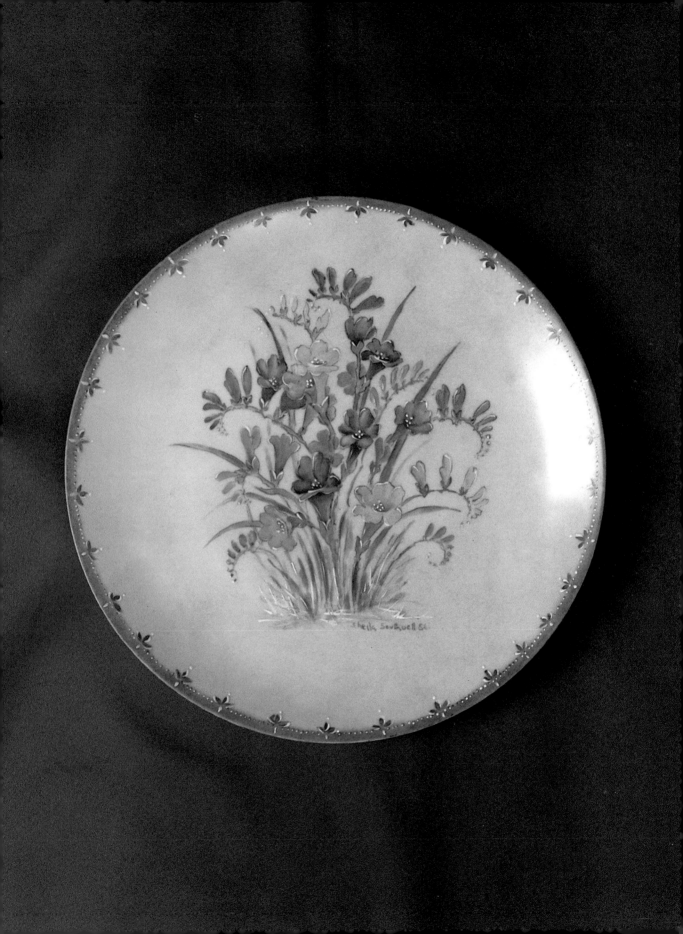

'All twinkling with the dewdrops sheen, the Briar Rose falls in streamers green.'

Sir Walter Scott

The wild rose is one of the most popular wild flowers with china painters and the large, evenly placed petals make it an easy subject for beginners. Other names of this flower include briar rose or dog-rose, and its tall bushes with their arching stems will commonly be found adorned with roses in early summer in hedgerows, woods and scrubland. It comes in many shades of pink and the trailing bracts make graceful forms to paint on many shapes of porcelain. This example was painted with brown-red leaves as a change from the usual green ones.

1st Fire

Sketch on the roses and leaves but not the stems at this stage. Using warm brown and blue-grey, filter a light background around the main design, gradually fading it out to pale yellow around the edge. Make the background lighter as you get further away from the main design. With pale pink paint a wash of colour over the rose petals, using very little paint and pulling the colour evenly down towards the centre of each petal. With light green paint in the little centre 'button' and wipe out a little highlight. Around this centre paint the area with pale yellow and yellow-brown. Wipe out a few highlights on the rose petals. With yellow-red paint a thin wash of colour on the leaves, keeping a few highlights here and there. Fire at 800°C.

2nd Fire

Add more colour around the main design paying attention to the areas under the petals, and tucking the colour well underneath. Filter colour out towards edge of the plate. Using deep rose, paint the shadows under the turnbacks on petals smoothing the paint with your blending brush, and maintaining all the highlights. Shade leaves with grey and yellow-red, and add a few veins. With yellow-red, paint a fine 'halo' around the outer centre of roses, and, using a fine toothpick, pull out the stamens and make little dots at the end of each one (make sure you do not get these all in a row). Paint the stems and thorns now, using light brown. Fire.

3rd Fire

All that is necessary on this fire is to deepen any colour that you think needs it. On this fire I used a fine pen and penned in a few shadow leaves and stems with light brown, and carefully filled in with a pale grey colour. I also made a few pen lines around the main design. If you decide to do this the pen lines must be extremely fine or it will look dreadful. Fire.

Colours used: rose pink, yellow-red, Copenhagen grey, light brown, lemon, yellow-brown.
Suitable shapes: Vases, plates, bowls, pitchers.

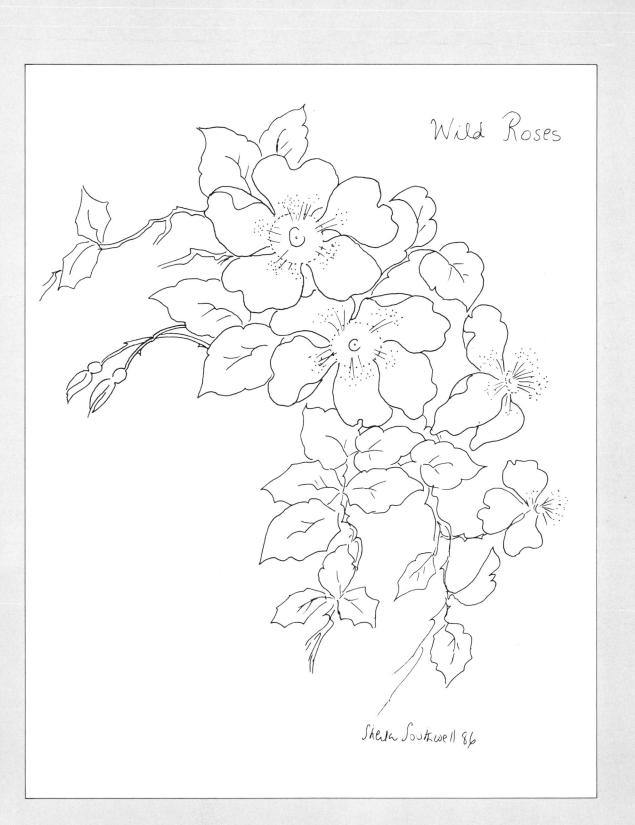

Wild Roses

Sheila Southwell 86

65

Briar Rose

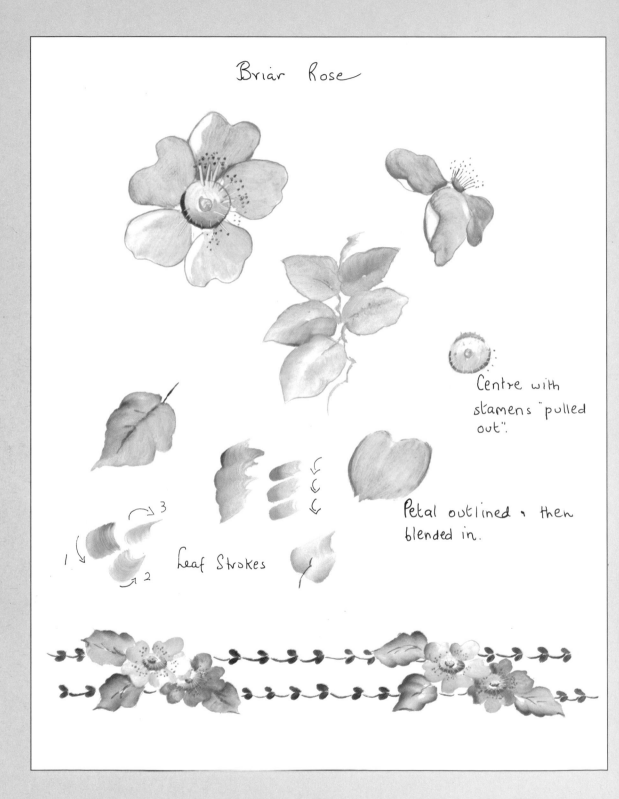

Centre with stamens "pulled out".

Petal outlined & then blended in.

Leaf Strokes

1

2

3

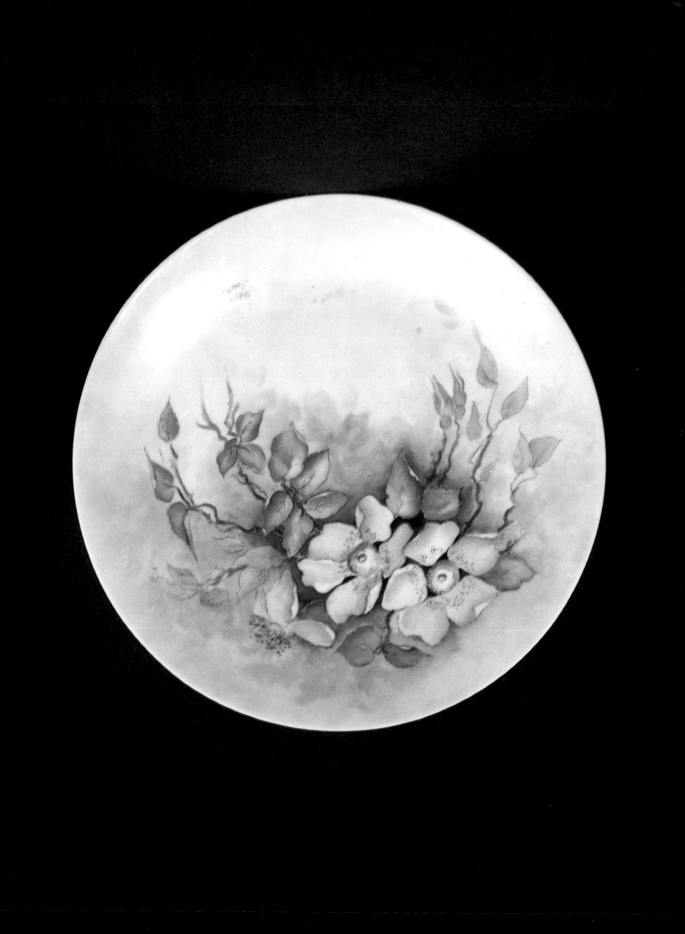

'Bend your long green leaves exotic orchid –
Your frilled petticoat richly adorned with ruby red.'
S. Southwell

Orchids are an exotic species which come in myriad shapes and colours from the subtlest white to the deepest shade of ruby red. The flowers may be produced singly on a long stem or in a spray. The flower often consists of a centre or lip, two lateral petals and three outer petals. The lip is often the most outstanding feature of the flower and can be very long in some species. It stands out from the rest of the flower and it is this which attracts the pollinators. Three outer petals complete the flower. Some orchids have a heavy fragrance and attract nocturnal insects. The leaves are usually straplike.

1st Fire

Lightly tint the plate with light green, lemon and pink and fire at 800°C.

2nd Fire

Sketch on the orchid and leaves, and paint a wash of leaf green over the leaves, wiping out a few highlights. Paint the orchid with ruby, shaping the frills on the lip of flower, and wipe out a few highlights and turnbacks on lipped petal. Fire at 800°C.

3rd Fire

Filter a little black-grape and ruby over the background close to the orchid. Deepen the colours on the leaves and flower. Blend a little yellow-brown around the orchid to give the background a warmer appearance. Wash a little yellow-brown on the turned-back portion of the lip petal. Paint the centre with yellow shaded with yellow-brown. Apply bright gold to the edge of the plate. Fire at 770°C.

4th Fire

Paint the deep shading on petals with American Beauty and black-grape. Add any further shading elsewhere on design. Apply burnishing gold to rim. Fire at 770°C. Burnish after firing.

Variations: vases, long dishes, ginger jars.
Colours used: ruby, American beauty, black grape, leaf green, olive green, yellow, lemon, pink.

Orchid

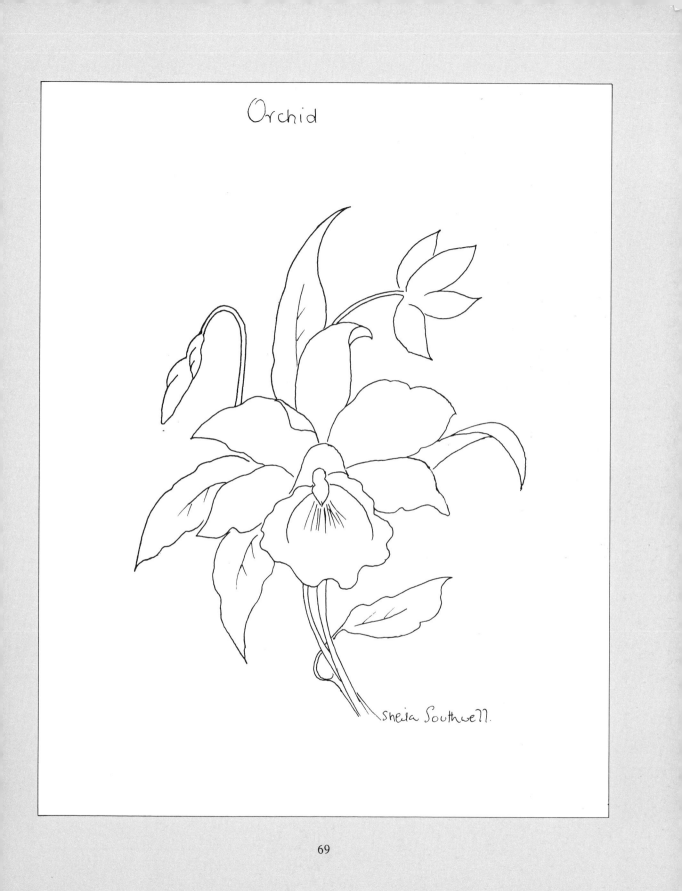

Sheila Southwell.

Orchid shapes

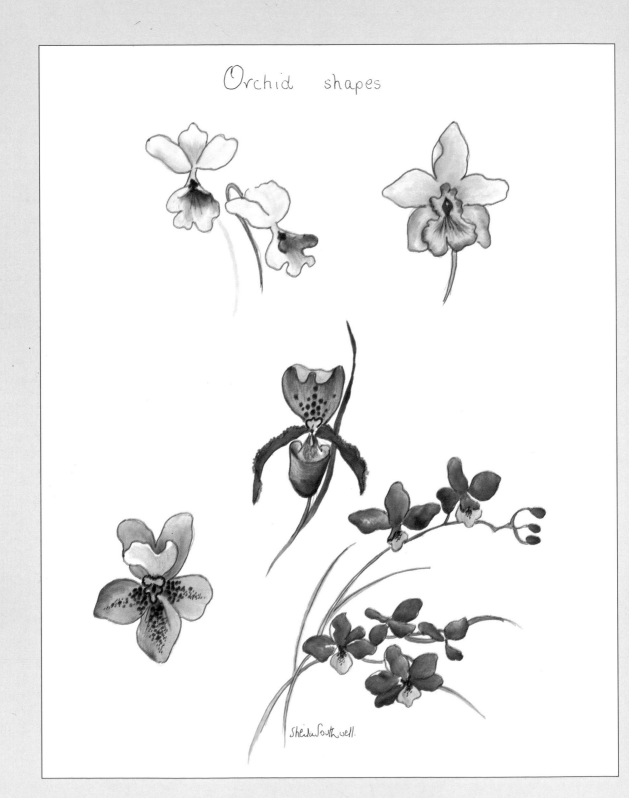

Sheila Southwell.

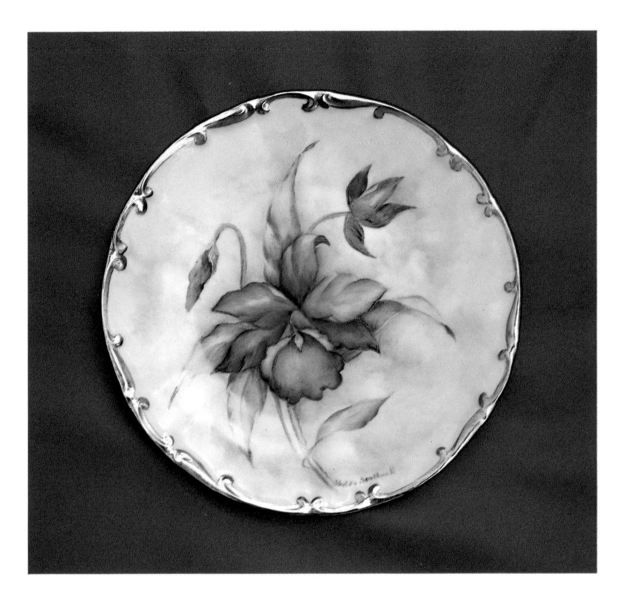

'I sipt each flower,
I chang'd ev'ry hour,
But here ev'ry flower is united.'
John Gay
The Beggar's Opera

Designs featuring 'all-over' florals necessitate the whole piece of china being covered with flowers, so if you have a slightly flawed piece of china (not cracked or chipped, however) you could safely use it for this type of design as no white surface will be seen on completion. Oriental flowers are particularly suitable for this design and it may be as colourful as you care to make it, or it may be done in different shades of one colour only with a gold or silver border. The little spaces in between the flowers are filled in with the same background colour of your choice, but black is very dramatic especially if a burnished gold border is applied. The flowers can be outlined in gold with a fine pen if desired.

1st Fire

Start by deciding on which type of flower or shape you intend to use, and then sketch several different types onto paper to give you an idea of how they will blend together on the china. After deciding, either sketch them onto the china with your pencil or a fine pen, using a fast-drying medium (by using a fast-drying pen oil you will be able to paint in the flowers straight away). The secret of this design is to cover as much of the surface of the piece as possible, leaving only very small spaces to be filled in later. Remember to overlap the flowers as you go, and do not give each flower a complete shape. Start with the largest flower and gradually fill in with smaller ones leaving the tiny daisy-like ones till last, as minute fillers. For the penned outlines of the flowers use either a light black, grey or other neutral colour. If you intend to outline the flowers later with gold then you should use only the lightest shade to pen them. You may find it easier

if painting a cylindrical shape to paint one side first and fire before doing the other side.

As soon as the penwork is completed and dry you can then start to paint in the flowers with the colours of your choice. Keep the colours clean and crisp, as the charm of this type of design lies in the spontaneity and surprise of the bright colours. When you have painted as much as you can without the risk of smudging it, fire.

2nd Fire

Add more colour where needed and fire.

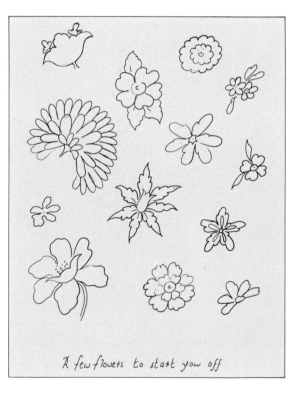

A few flowers to start you off

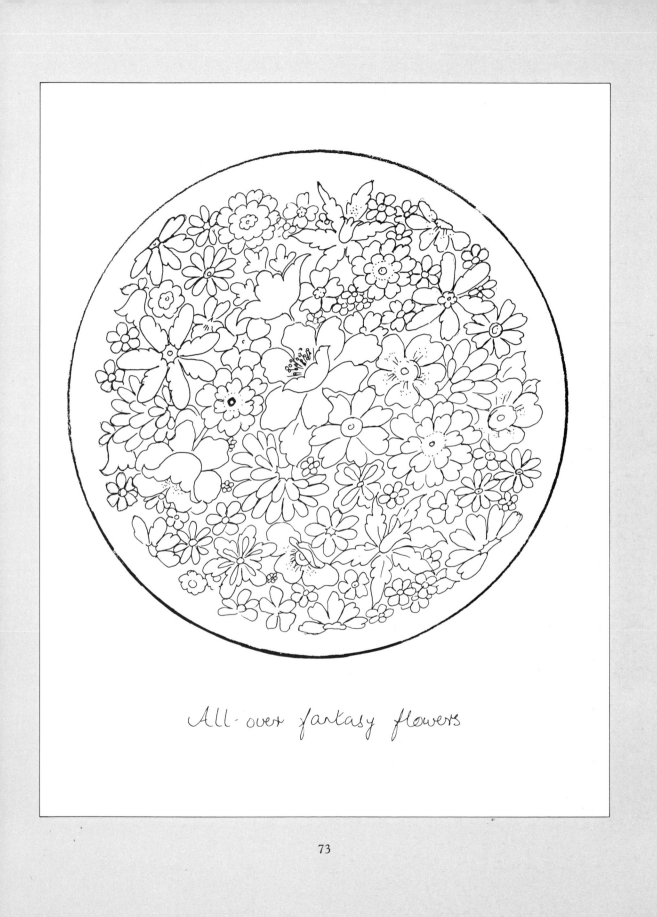

All-over fantasy flowers

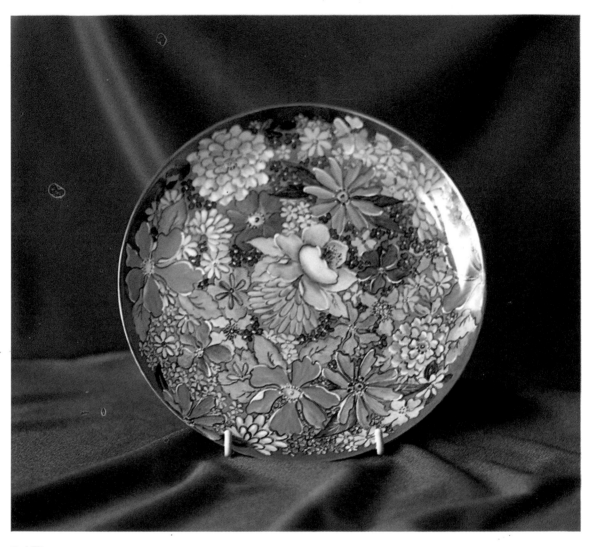

3rd Fire

Paint in all the little spaces around the flowers using a small brush and getting into all the tiny crevices between the flowers. Fire.

4th Fire

Add any more colour now. Paint in the gold border around the plate, being careful not to let the gold touch any wet colour – fire.

5th Fire

If you intend outlining the flowers with gold, do it now using an extremely fine nib and keeping the outlines neat. A great deal of care is needed when doing this, as you must make as few mistakes as possible to avoid having to keep wiping the gold off. Add another coat of gold to the border and fire. Burnish the gold.

Variations on a theme: leaves all over, flowers of one type (e.g. pansies), all wildflowers, different berries, fruits all over.

Suitable shapes for this type of design: large vases, bowls, plates, ginger jars, large bells.

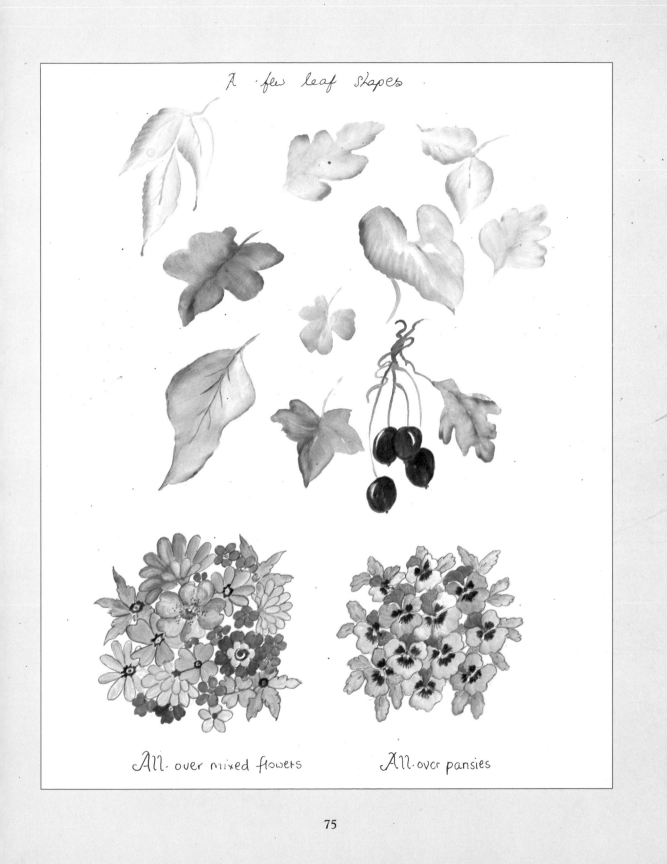

A few leaf shapes

All over mixed flowers

All over pansies

'The little lanes of Somerset
Are narrow and lost and green
The sunlit trees show leafy aisles
With dappled shade between.'
Teresa Hooley

This was done in the same way as the all-over flower plate except that the edge section was painted with thousands of little dots to complete it. With these dotted areas (called pointillism) it is a good idea to establish a rhythm when making the dots otherwise they become misplaced and often mis-shapen. Listening to music whilst painting helps – believe it or not, the 10,000 plus dots were done in time to the *West Side Story* soundtrack. It took the whole album time to complete the dotted area plus a bit more so you need plenty of patience. Pointillism can be a tiring method of decoration and short breaks from it are recommended otherwise you will find yourself going cross-eyed! The dots should be closer together nearest the design, which gives a darker area.

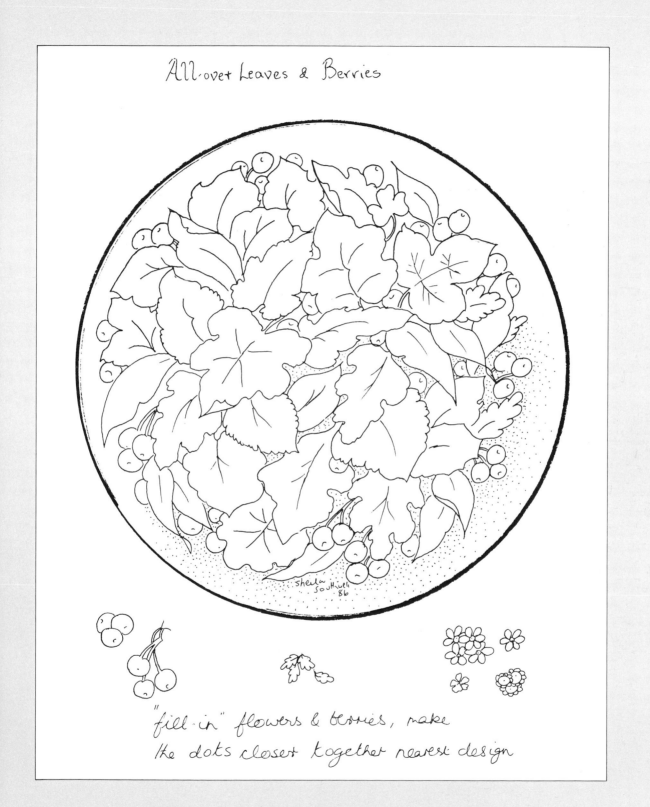

"fill-in" flowers & berries, make
the dots closer together nearest design

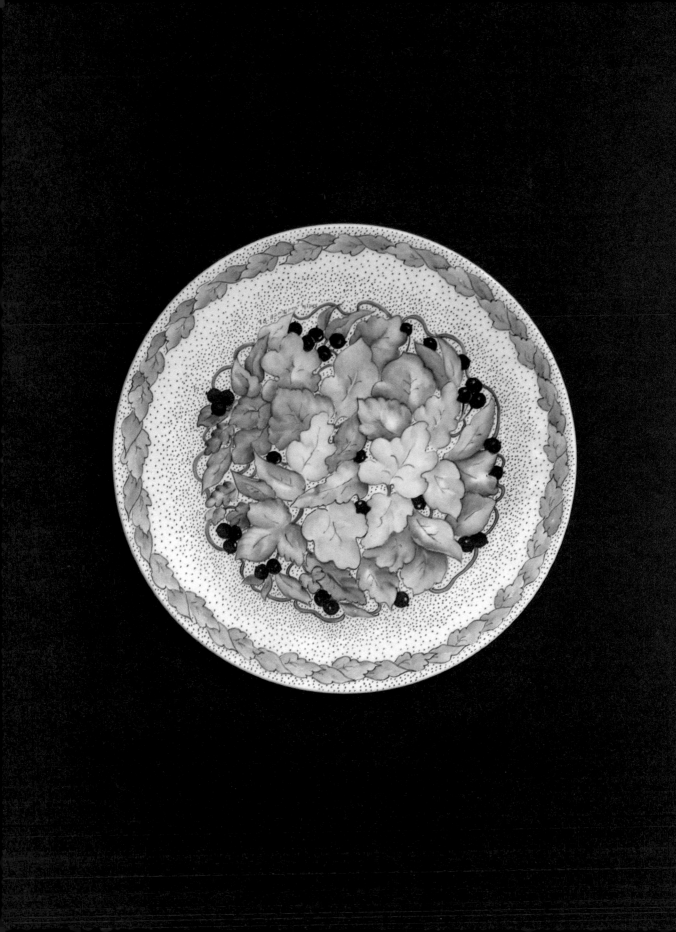

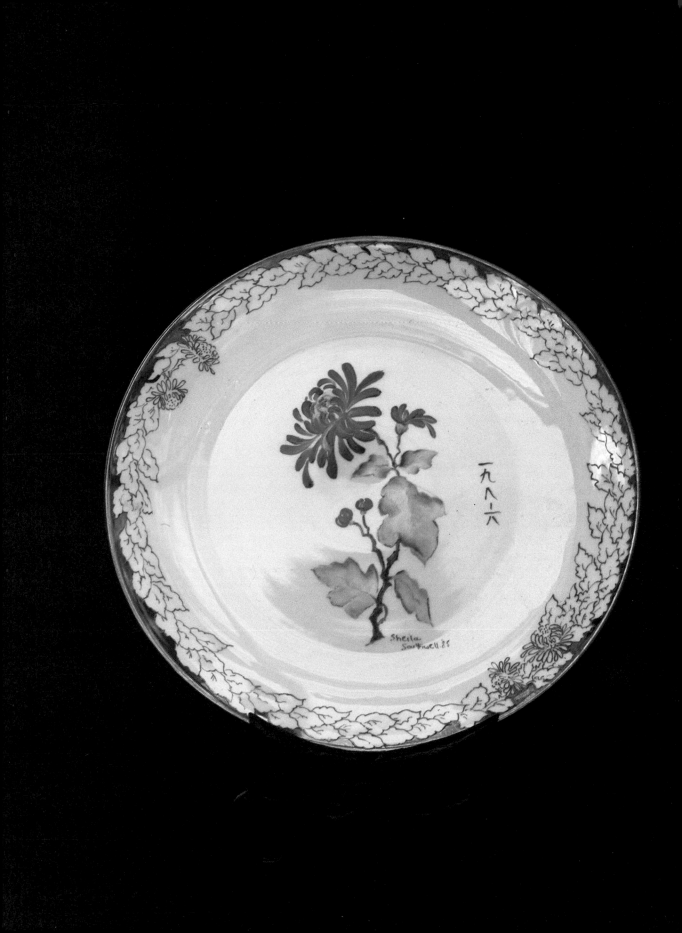

'With flowers and gold and azure dy'd
Of ev'ry house the grace and pride
How white how polish'd is their skin
And valu'd most when only seen.'
John Gay

The chrysanthemum in its various forms is one of my favourite flowers to paint. The oriental style has a quiet tranquillity and is much loved in Chinese and Japanese art. It is the Chinese symbol for autumn, and many books have been devoted entirely to this one flower, and its application. I have included both an oriental and naturalistic version for you. Because chrysanthemums come in many forms and colours, they lend themselves to all sorts of porcelain design but look best on large vases and plates. Beginners consider the 'mum' is difficult to paint, but providing one or two points are remembered it is surprisingly easy once the brush strokes have been mastered. Remember the petals radiate from a centre point and the base of each petal must be in line with this – see sketch. The petals grow in an irregular fashion overlapping each other in different ways and some are very shaggy in their appearance. The oriental ones are usually painted onto a white background whereas the 'naturalistic' ones are wiped out of a painted background, but there is no general rule.

ORIENTAL CHRYSANTHEMUM

I used royal blue for the design of the flower and also for the penned border and the Chinese writing which means 1986. The plate was completed in two fires.

1st Fire

Sketch the design onto the plate and paint, using royal blue on the petals and yellow-green on the centre. Leaves are painted with yellow-green shaded with dark green. The petals must be made with one stroke only pulling it down to its radiating centre; use a good pointed shader and enough paint to complete each petal in one go. Wipe out highlights on leaves and petals. Paint the stem with brown-green and the little flower buds with blue. Form the outside plate design with a pen, using royal blue mixed with your pen oil. Start with the little flower design at one edge in the border and then sketch the leaves, keeping them a uniform size and the same distance from the edge of the plate. Do not allow any 'stray' leaves to jut out of the border area; allow about ½ inch of border at the outside edge for the copper on the next fire. Fire at 800°C.

2nd Fire

Add any additional shading necessary to flower and leaves, and using a pen and royal blue do the Chinese writing (1986 in this instance). Using copper, or gold if you prefer, carefully paint the border. You will need a small pointed brush to get in between the small leaves, as the copper must go right up to the leaves but not over them or you will spoil the shape. Fire at 780°C. If the copper needs another coat you will have to do it and fire again.

Colours used: royal blue, yellow-green, moss green, copper, brown-green.
Suitable for: vases, sandwich dishes, teapots, plates, ginger jars.

NATURALISTIC CHRYSANTHEMUM VASE

The vase illustrated was painted and fired ten times in all and is 18 in tall. It only just fitted into my kiln and because of its size and weight, I could not work on it for too long at a time. One side was completed before starting on the other and a little pen work was

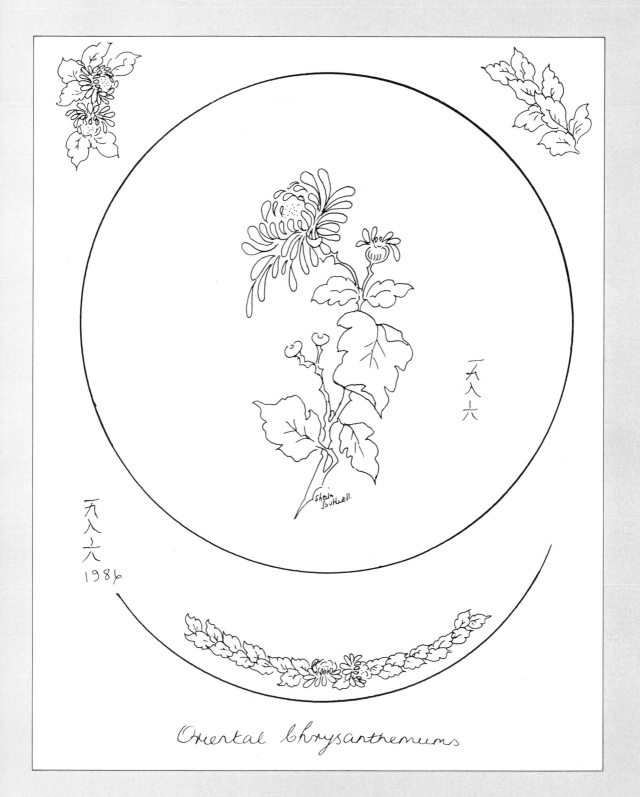

一九八六

一九八六
1986

Sheila Southwell

Oriental Chrysanthemums

81

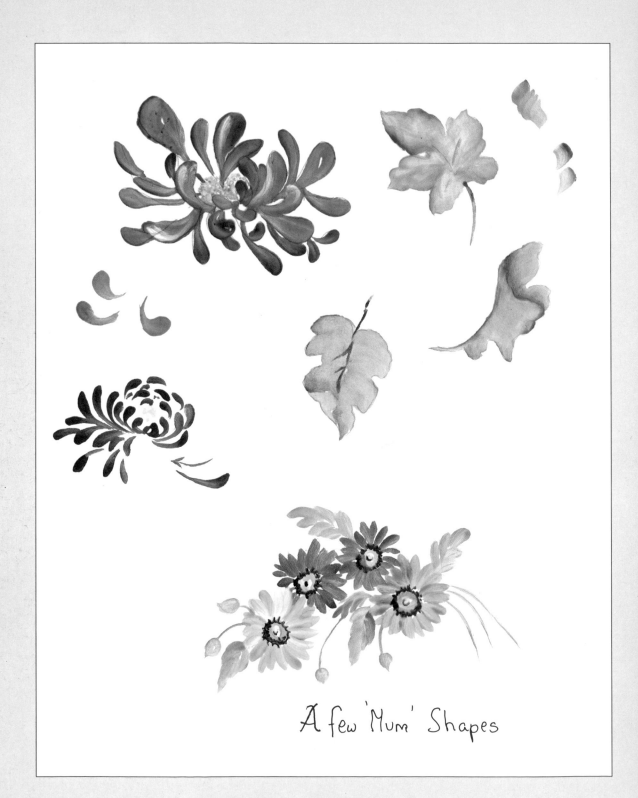

A few 'Mum' Shapes

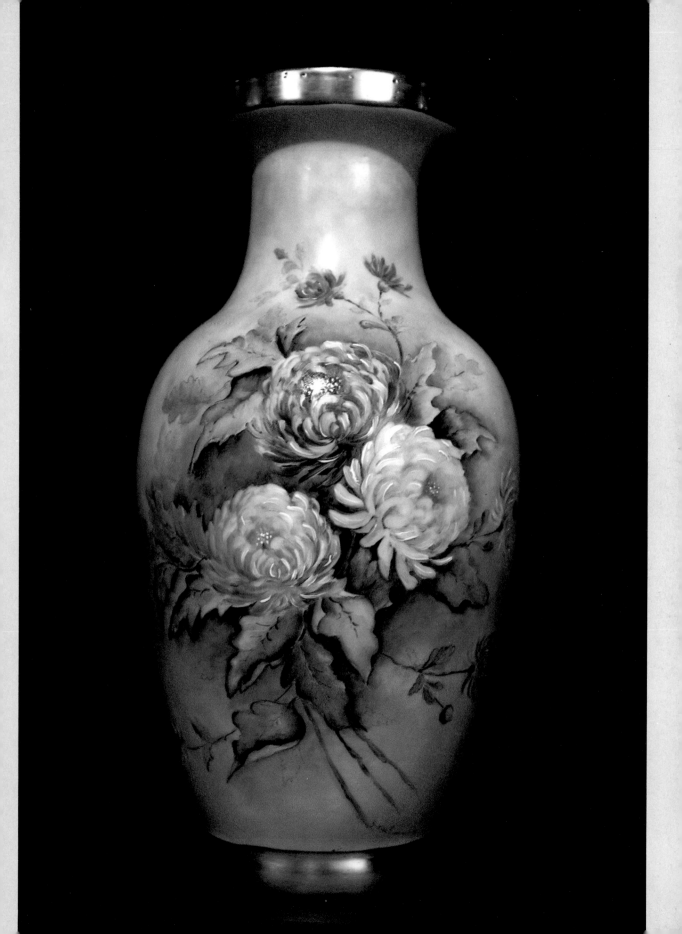

added on the last fire. Roughly sketch on the position of the flowers, and do not bother to trace every single petal.

1st Fire

Block in the flowers with American Beauty, ruby, yellow-brown, yellow and ivory (the white one was painted with Grey-for-flowers and copen blue and light olive green). The centres were done with yellow-brown with a little green. When painting the flowers be aware of how the petals radiate from one lower centre place and paint the brush strokes accordingly in that direction. Proceed by wiping out the petals with a no. 4 round brush but do not take out too much colour on the shadow side of the flowers. Paint a wash of yellow over the leaves and then paint in the buds. Fire *slowly* at 820°C.

2nd Fire

Add a background around the main design using navy blue, brown, yellow-red, pink and ivory, shading it out almost to nothing at the sides – if you have the colour too dark where you finish shading you will get a harsh line when you come to join up the backgrounds on the back and front of the vase. Add more shading to the leaves and flowers where necessary. Paint the stem. Fire at 820°C.

3rd Fire

Paint a complementary design on the reverse side of the vase. Fire at 820°C.

4th Fire

Add the background over the back of the vase, padding with silk where the two background colours on the back and front meet so there is no line. Fire at 820°C. It is important when firing very large pieces to fire them slowly to avoid unnecessary damage.

5th and Subsequent Fires

Keep adding colour until you are satisfied with it. The white enamel was added on the last fire and the gold took two firings, burnishing after the last one. A little penwork was added on the last fire to suggest a few shadow leaves.

Colours used: American Beauty, ruby, grey-for-flowers, yellow-brown, navy blue, brown, yellow-green, dark green.

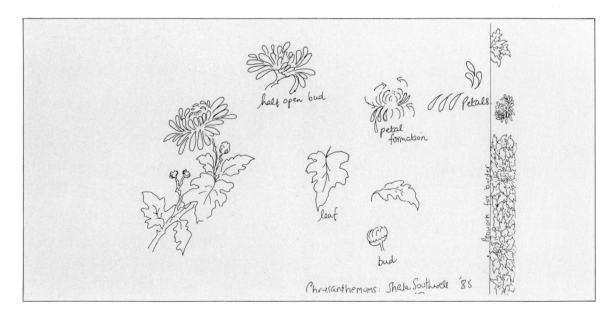

Chrysanthemums: Sheila Southwell '85

84

Naturalistic "mums". Sketch on only the basic flower shape. all
detail is done with the brush.

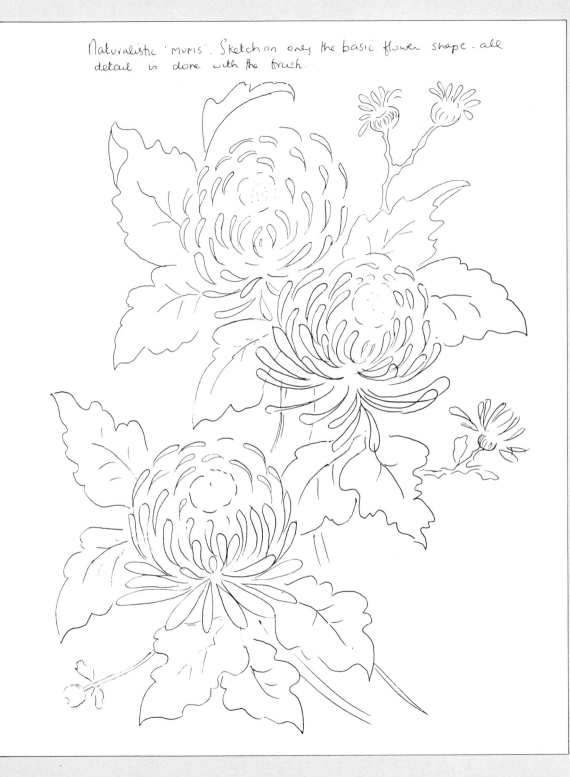

'An England without roses could there be?
Best loved of flowers for many a century:
In simple cottage plot beside the door
Their homeliness endears them even more,
But placed in stateliest gardens graciously
The rose holds pride of place with dignity.'
Marion Irene Holmes

PALE PINK ROSES

1st Fire

Sketch design onto china and lightly paint the roses with pale pink, making the centres darker. Pull your colour well down into the throat of the flower, painting the shadow side slightly darker than the light side. Wipe out the highlights and turned-back petals keeping the edges crisp and sharp. Frame the roses with background now, using blue-green and baby blue with a little pink out towards the edges of plate. Paint a wash of yellow-green on the leaves. Wipe out the flower centres. Fire at 800°C.

2nd Fire

Apply a little pink and soft ruby to shadow areas under petals and turn-backs. Deepen the background with blue and blue-green. Paint the centres with Albert yellow. Add some shading to the leaves with blue-green and shading green. Paint in the stems, not forgetting the thorns. Apply a good border of bright gold and fire at 760°C.

3rd Fire

Apply any more necessary colour on background and a coat of burnishing gold to border. Fire at 760°C. Burnish gold after firing.

Colours used: rose pink, ruby pink, yellow-green, shading green, blue-green, baby blue, Albert yellow, brown.

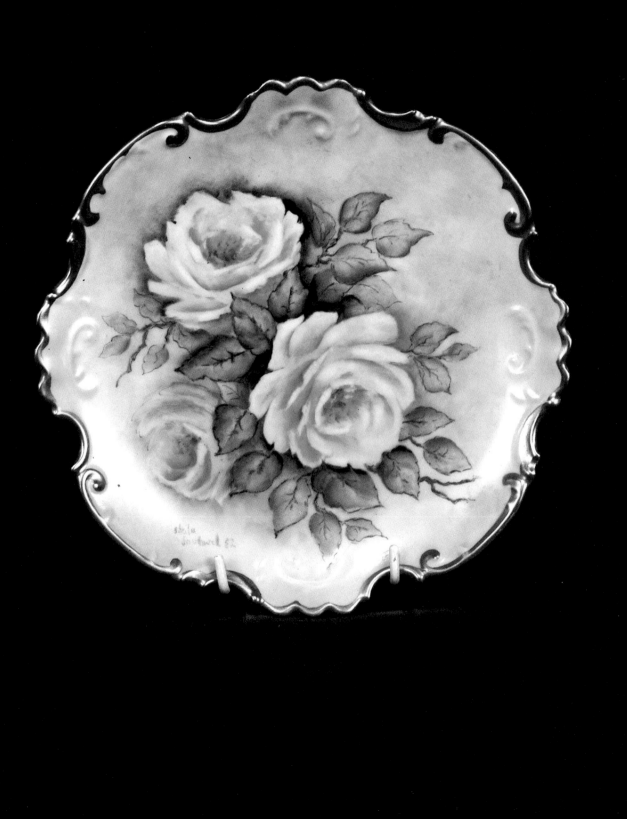

Pink open Roses

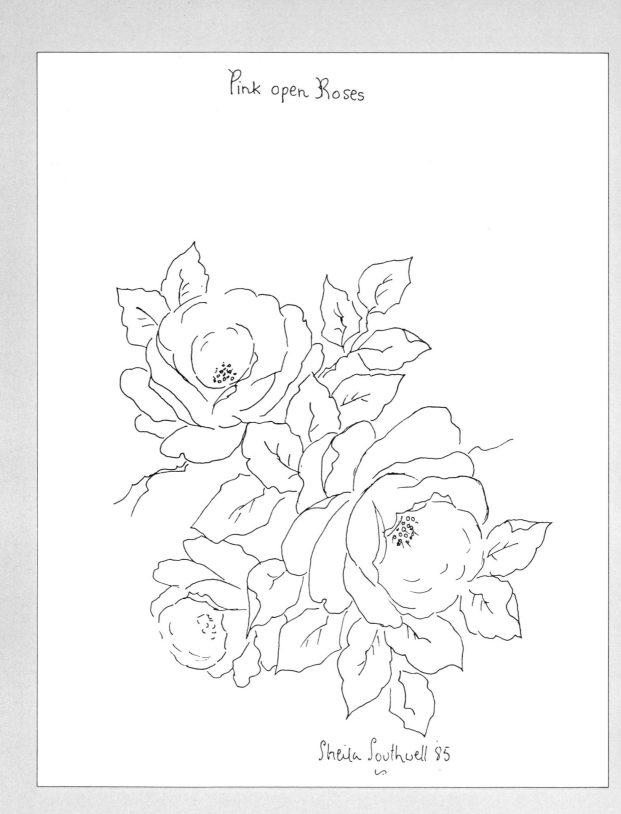

Sheila Southwell '85

'PITCHER-SHAPED' ROSES

'It was roses, roses, all the way.'
Browning

Painted on a bone china plate, this design was completed in one fire, but you could take more fires if you prefer. The roses are very loosely painted with ½ in square shader brush.

Lightly sketch the roses onto a plate. Using brown-green and dark green filter strokes around the main design forming a shadowy background, and continue filtering colour out towards the edge of the plate using a soft blue-green and pink. Paint in the roses using maroon for the throat of the rose and American Beauty for the rest of the flower. Pull the maroon down into the throat of the flower, making it very dark, and keep the shadow side of the rose darker. Paint the petals very loosely using a relaxed motion of the brush; this needs to be practised on a tile first, as the lower petals are suggested rather than actually painted in detail. Brush a little background colour lightly over the roses here and there using a soft blending brush. Wipe out highlights and turn-backs with a wipe-out tool and then with a dry brush soften these wipe-outs. Using a side-loaded flat shader brush, paint the leaves with yellow ochre and brown-green, making each leaf with three strokes – this also needs a little practice, as they are painted wet-in-wet into the background. The centre vein is wiped out with a tool and the stems lightly indicated with brown. The scrolls are added with a number 5 scroller brush. Fire at 800°C.

Suitable shapes: plates, vases, jugs, teapots.
Colours used: maroon, American Beauty, bronze green, ochre, blue-green, dark green.

Pitcher - shaped Roses.

Sheila Southwell '83

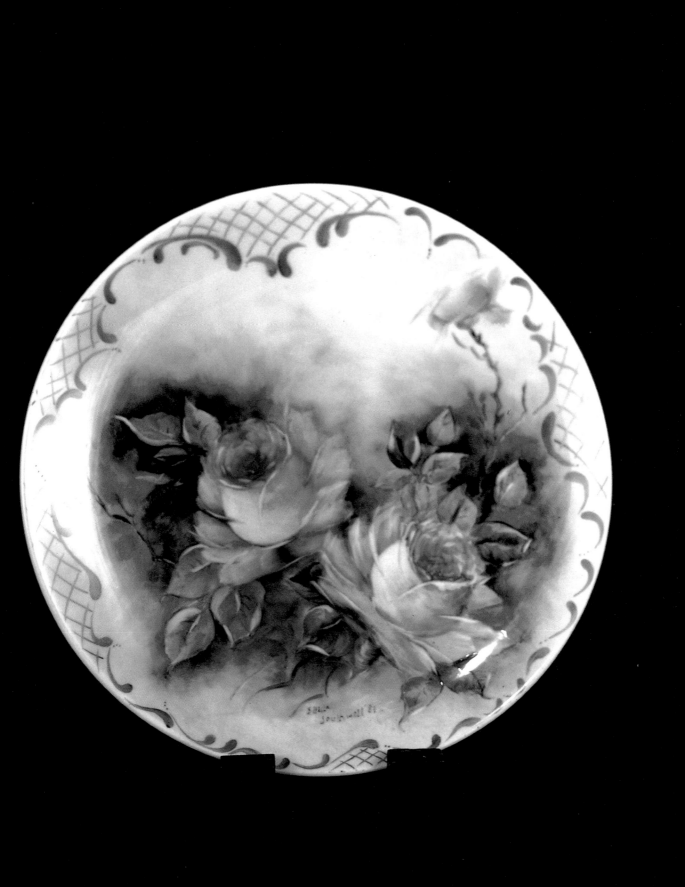

VASE WITH RED ROSES

'Sweet spring, full of sweet days and roses,
A box where sweets compacted lie.'

George Herbert

This large porcelain vase was painted and fired twelve times in all, working first on one side and then the other. The top and base were fired separately and glued together afterwards. The vase was purchased from abroad and when I came to paint it I realised that it tilted to one side, and a filler had to be made to make it stand up straight. Bear this in mind when buying vases of this sort as they are expensive and it is not always possible to exchange them.

Use a reliable red — I used ES Colours yellow-red Number 22.

1st Fire

Trace on the design roughly — just enough to give correct placement of flowers. Paint the roses with yellow-red, making sure you use a good reliable red as this vase will be painted and shaded many times. Paint the leaves with yellow-green and a little ochre. Wipe out highlights on the leaves and flowers. Fire at 820°C *slowly*.

2nd Fire

Paint in the background, keeping it darker under the main design. Filter the background colour out almost to nothing towards the edge of vase. Add more colour to leaves with shading green and more colour to the roses using blood red and ruby, maintaining the highlights. Fire at 820°C.

3rd Fire

This fire was used to concentrate on the leaf stems and veins and I also added a little more background colour.

4th Fire

This fire was used to establish the design on the reverse side of the vase, which consists of pink roses.

5th and Subsequent Fires

Used to add more colour where needed. The last two fires were for the burnishing gold which was fired at 760°C.

Colours used: ES Colours yellow-red No. 22, ruby, blood red, yellow-green, yellow-brown, brown, shading green, water green, blue-green, Meissen green.

Red Rose Vase.

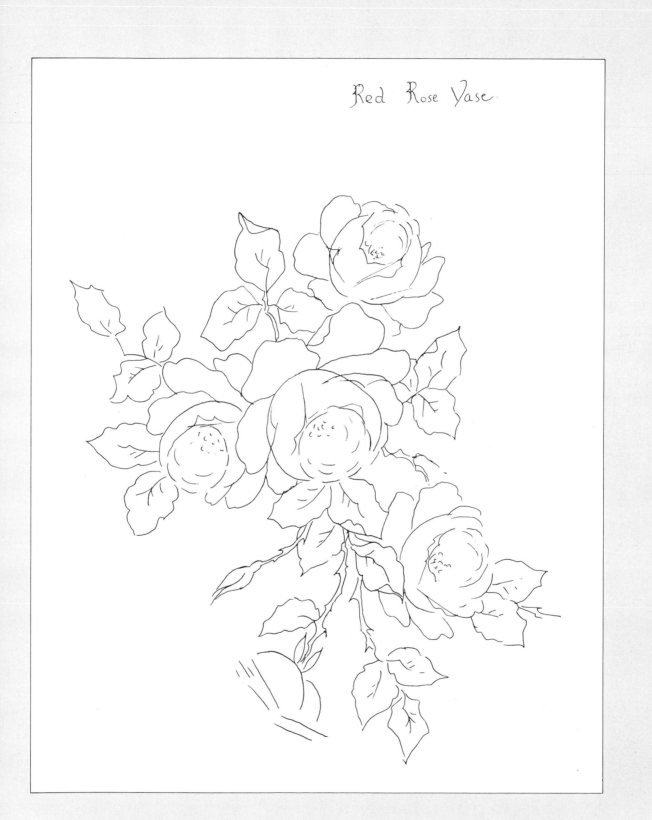

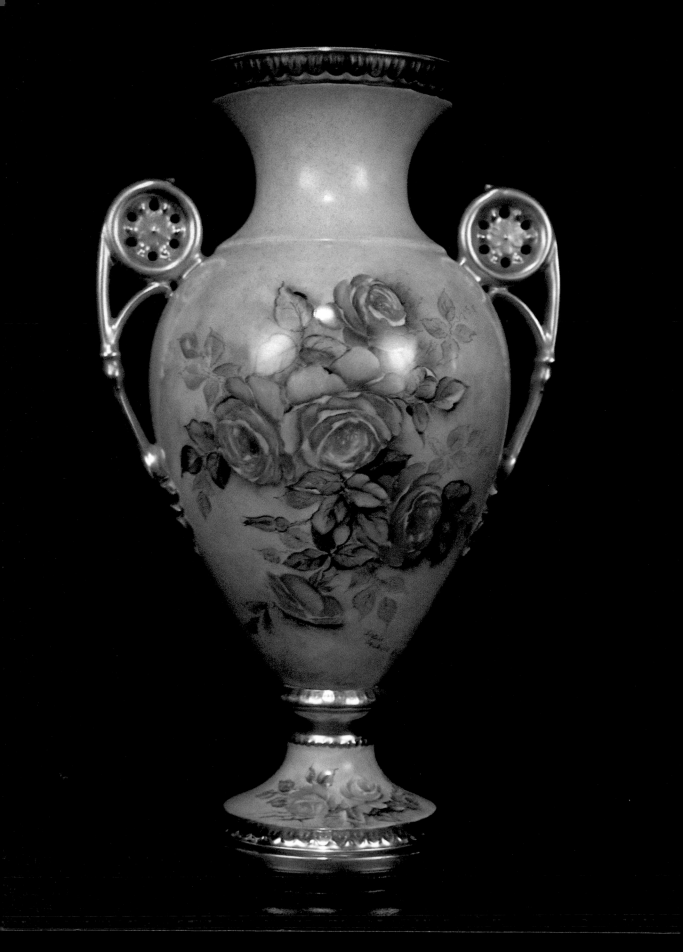

'Season of mists and mellow fruitfulness,
Close bosom friend of the maturing sun;
Conspiring with him how to load and bless
With fruit the vines that round the thatch-eaves run.'

John Keats

Blackberries, like grapes, may be more difficult than other fruits for the china painter but they are one of the most popular and rewarding subjects and I have found that pieces painted with these luscious berries are almost always the first pieces to sell at exhibitions and are among the top three of my favourite subjects to paint. They look especially beautiful if used with a burnished gold decoration as the gold looks very rich when combined with the ruby and blackberry colours. The fruits are perfectly round and similar to grapes, as they are each spherical, but the grape is one complete sphere, where the blackberry is made up of many spheres which each contain a seed. Care must be taken to maintain their rotundity when painting. The seeds overlap each other so only a few complete ones are seen: these are the ones nearest to you and must be lighter in colour. Where two berries overlap the one underneath must be darker than the one on the top, otherwise when fired you will have one weird shaped berry. This also applies when you have several berries together, as each one must have its own shape and reflections. Do not forget to show some reflected light on each one; it will be at the bottom of the berry in the darkest area where a little light will be reflected from the berry underneath. The flowers are pale pink and these make a lovely study on their own. Because blackberries are a particular favourite of mine I have included several pieces on this theme.

VASE WITH GROUNDLAY AND GOLD

This project is performed using the groundlaying technique (as described on page 33) leaving the reserved panel for the berries. The gold was done with a fine pen and applied on the final firing. This technique was initiated by Meissen in 1722 when a rich brown *(Kaffeebraun)* was first used; later yellow, green and crimson were introduced. At Sèvres in France, the dark *gros-bleu* was used in 1749 and *bleu-céleste* and *jonquille* yellow in 1752. In 1756 they introduced the lovely rose Pompadour and other colours. Similar colours were used by English potteries, each having their favourite. In my opinion this is the most difficult decorating technique and a great deal of practice is needed. The effect of using a sponge never gives the same result as the conventional groundlaying technique, though it is considerably easier to do. You will not get perfect results until you have practised for quite a time, especially if groundlaying around handles and other awkward areas, but all the trial and error of this technique will be well worth it when you produce your first well-grounded piece with its brilliant high gloss and deep colour. This piece took quite a lot of firings and only good quality china should be used for it.

Always use a face mask when using the powdered colours in large quantities. Some colours give better results than others and those easiest for the beginner include yellow and leather green and pale blue; if you are doing it for the first time avoid dark blues and damson and ruby colours.

Method

First mask off the reserved panel to be used for the berries and allow it to dry, also mask off the handles on vase.

1st Fire

Proceed with the groundlaying technique as described on page 33 removing the masking fluid after using the silk pad and *before* applying the powdered colour. Before firing the piece will have the appearance of suede leather where the paint has adhered to the oiled surface, with no light and dark areas.

2nd Fire

Paint the berry design on the reserved panel and fire at 820°C.

3rd Fire

Add any shading to the design and fire at 820°C.

4th Fire

With raised paste carefully make the design around the reserved panel and fire at 760°C.

5th Fire

Carefully cover the raised paste with burnishing gold and also apply the gold to the handles and lid. Fire at 760°C. Burnish after firing.

6th Fire

Add a few little touches of raised white enamel to the berries and seeds, and another layer of gold to the raised areas and handles. Fire at 760°C. Burnish.

7th Fire

Using a fine pen and burnishing gold, make little pebble-shaped circles all over the groundlaid area making sure they are placed very close together. Fire at 760°C. Burnish after firing.

BLACKBERRY PLATE

1st Fire

Sketch on the design using circles, merely indicating where the berries are to go. It is not necessary to draw in each little seed, as this will be done with the brush.

Using American Beauty, yellow-red and brown filter some background around the design, then adding lemon, violet and pink as you near the edge of the plate. Paint a wash of yellow-green over the leaves, shaded with a little yellow-brown to indicate autumn colouring. Paint the berries, forming the little seeds as you go with a berry brush (a brush with short rounded hairs) using American Beauty for the bottom of the berries which are in shadow, and blue for the top of berries. Wipe out little highlights on each seed in the lightest part of the berry but not on every one in the shadow. Wipe out the blackberry flowers with a clean brush from out of the darkest area of background. Fire at 820°C.

2nd Fire

Deepen the background colours where necessary, especially around the blossoms, but pull a little background colour over the blossoms giving the effect of the shadow of the background. Add more colour to the berries, being careful not to lose their round shapes, using American Beauty and black grape on the darker side and ruby and blue on the lighter side. Wipe out the highlights again, and shade the leaves with shading green and a little yellow-brown. Paint in some stems at this stage, and add the centres to the berry flowers. Now whilst the berries are still wet use your very finest brush to 'pull out' some little hairs around each one; these must be very short and light and not too noticeable, otherwise they will look clumsy. Fire at 780°C.

3rd Fire

Using a very fine pen, draw some shadow leaves here and there and lightly outline the flowers and stems. This is called shaping up with a pen and is very attractive if done on the 3rd fire; it is definitely not the same as drawing the initial design in with a pen and then filling with colour. With water-green carefully wash some colour over these shadow leaves, and then some pale pink over the flowers. Adjust any colouring on the leaves, background and berries and fire at 780°C.

Beautiful Blackberries

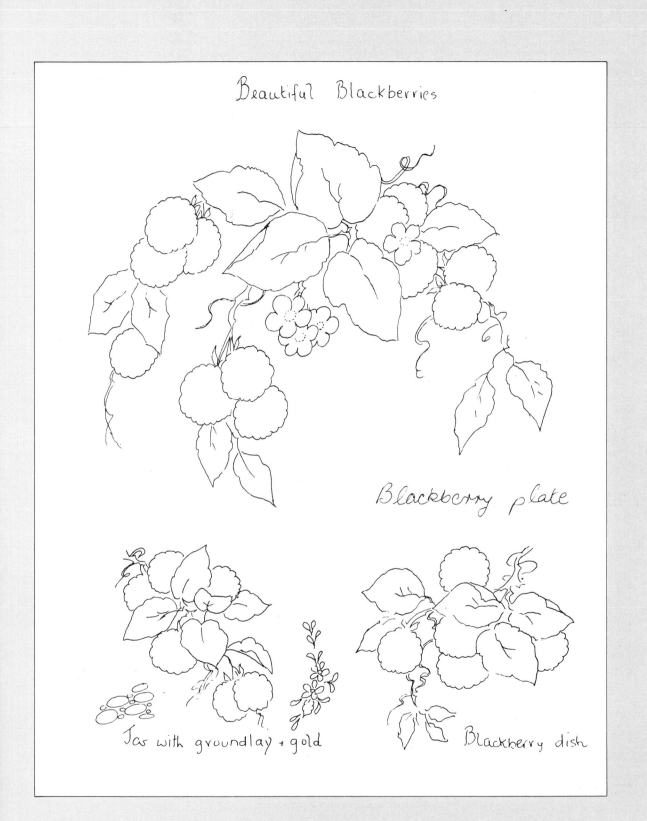

Blackberry plate

Jar with groundlay + gold

Blackberry dish

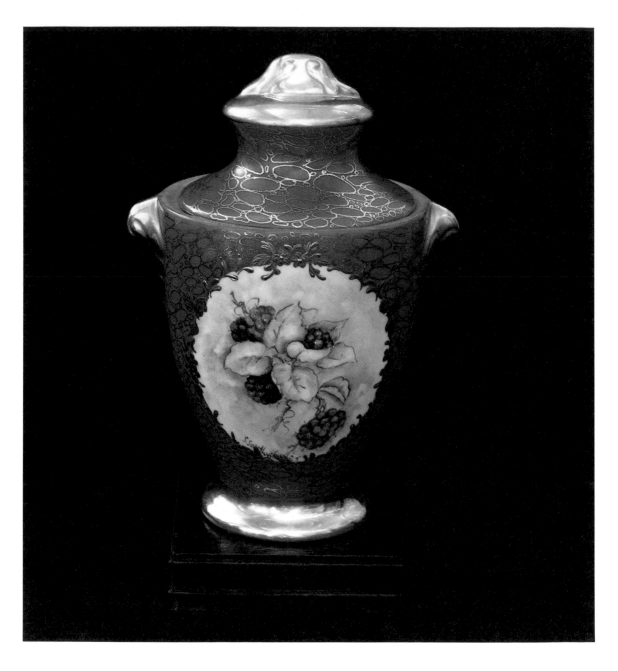

4th Fire

With white enamel, add a little highlight to some of the petals and make minute dots here and there on the most prominent berries to resemble little seeds. This must be done with great care with your finest brush because if the dots are too big they will look dreadful, and must only be visible on close inspection. Apply coat of liquid bright gold, and fire at 760°C.

5th Fire

Apply burnishing gold and fire at 760°C. Burnish after firing.

Colours used: American Beauty, black grape, ruby, yellow-brown, yellow-green, shading green, pink, lemon, violet, white enamel, baby blue.

BLACKBERRY DISH

1st Fire

Sketch design onto the china and filter a wash of lemon, pink and water-green on the background. Paint the leaves with yellow and yellow-brown. Paint the berries with violet and damson, and the stems in brown. Fire at 820°C.

2nd Fire

Deepen the background colour around the design. Paint a little yellow-brown on the leaves here and there, and shape up the berries with black grape and ruby. Fire at 820°C.

3rd Fire

With a very fine pen, outline carefully and lightly with black, adding the little veins. Outline the stem and add some little leaves at the bottom of the dish, and give these a light wash of yellow-brown. Apply band of gold around rim and fire at 770°C.

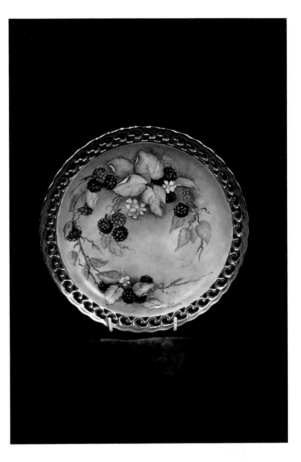

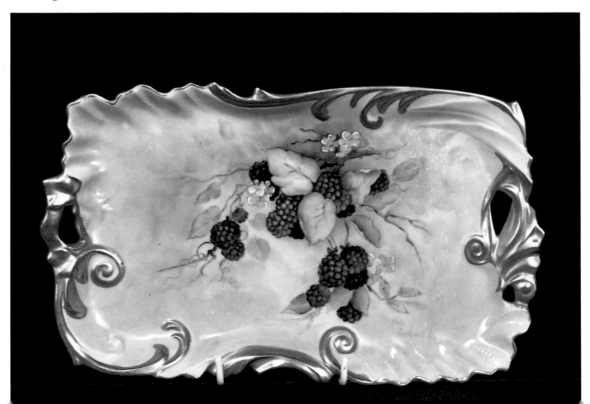

*'Wild are the waves when the wind blows
But the fishes in the deep
Live in a world of waters still as sleep.'*
Walter de la Mare

1st Fire

With fine pen and very pale grey ink, outline the whole design. Paint the little boats with deep black. Fire at 800°C.

2nd Fire

Apply a light wash of colour to the scene, using malachite blue for the sky and sea, lilac for the mountain, yellow red for the distant hills, ochre and salmon pink for the cliffs on the left side, sky blue for the lake and three different shades of green for the foreground. Leave the large wave white, as this will be covered with a layer of mother-of-pearl lustre later on. Fire at 800°C.

3rd Fire

Add some shading to the sky, and the scene, using the same colours. Paint in the pine trees using black. Deepen the sky and the sea using more malachite blue. Give these areas 'movement' by using your brush with a swirling motion as you paint. Now use a large blending brush to swirl the colour on the sea area, as this gives the design impact and a Japanese 'feel'. Fire at 800°C.

4th Fire

Add a little more colour to the scene but not too much, as this area must be made to recede slightly. Paint a layer of mother-of-pearl lustre over the entire large wave. Fire at 770°C.

5th Fire

Using matt relief enamel, apply a thick layer to resemble foam on the surf, placing it on the outside part of the wave only (but don't touch the inside portion of the wave, so that the layer of pearl is left mostly untouched). In some parts I've used little scrolls but mostly it is stippled on. Fire at 770°C.

6th Fire

Apply more matt enamel, making the big wave more prominent. Use the enamel to accentuate the mountain top to resemble snow, and apply a little to the general scene. Fire at 770°C.

Colours used: malachite (blue-turquoise), yellow-red, sky blue, violet, salmon pink, ochre, chartreuse, moss green, shading green, bronze green, black, matt relief white enamel No. 401.

Mt. Fuji Fantasy

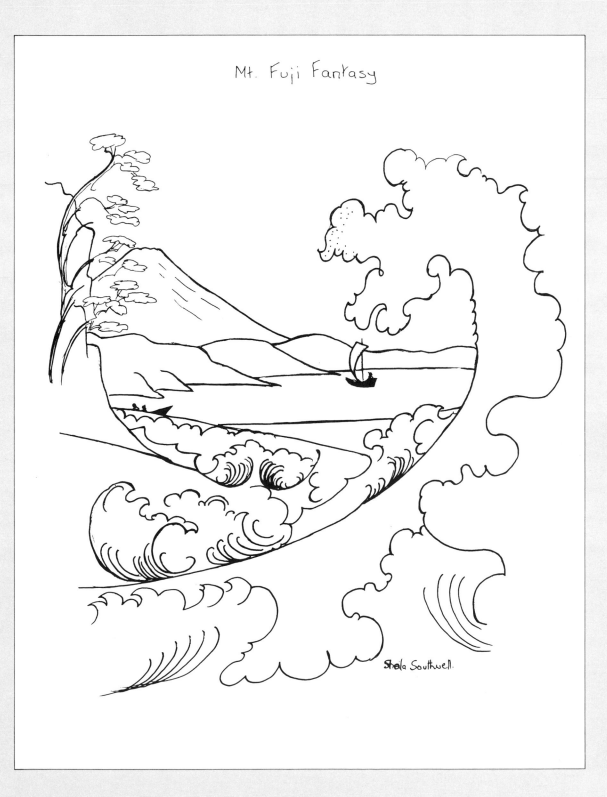

Sheila Southwell.

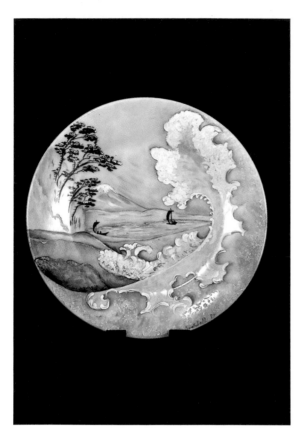

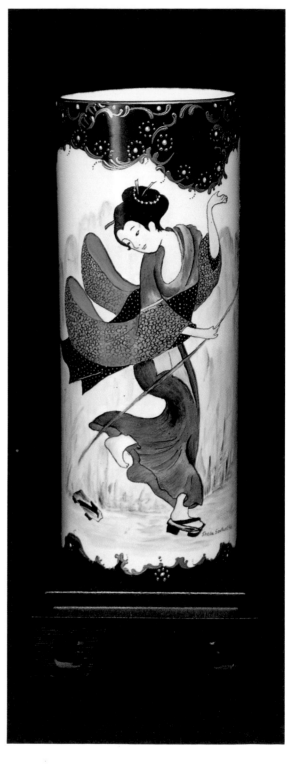

Suggested design for back of vase

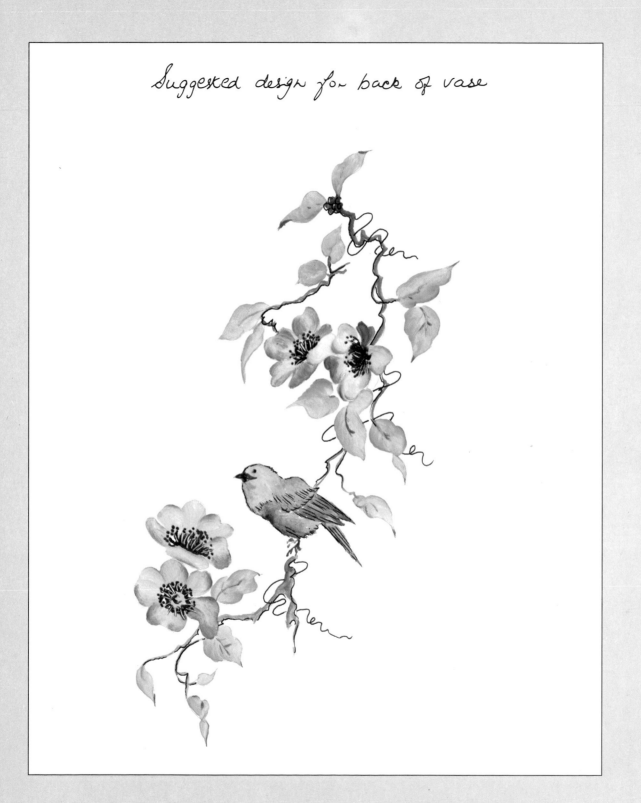

'When I some antique jar behold
Or white, or blue or speck'd with gold
Vessels so pure and so refin'd
Appear the types of woman-kind,
Are they not valu'd for their beauty
Too fair, too fine for household duty.'
John Gay

BONE CHINA: SEVEN FIRES

This vase had flaws on the base about an inch high, so I decided to use a dark background to balance the top border. Japanese designs are a pleasure to paint, as the imagination can run riot regarding colours and special techniques such as enamelling, gilding, lustres, etc. I chose this design as I felt that the figure had lots of movement and could convey the mystique and gorgeous colours of the Orient.

1st Fire

Trace or sketch the figure, using a fast drying pen medium, but putting no detail on the kimono. Then apply a deep wash of colour on the kimono using yellow-red, chartreuse, black, blue-violet and maroon. Wipe out a few highlights in the folds of the skirt. Apply a wash of colour on the face and limbs. Fire.

2nd Fire

Shade the dress and hair with the brush strokes, following the line and flow of the folds in the garments. Colour the hair and sash a deep black. Using pale grey, indicate the top and bottom shapes of the border to be groundlaid on the next fire. Fire.

3rd Fire

Using black, groundlay the top and bottom border panels. Fire hot (800°C for bone china, 820°C for porcelain).

4th Fire

Adjust any shading on the figure and paint in the design on the back of the vase; this can be done in one fire, using a fast-drying pen medium. When dry, shade in the flower and the bird.

5th Fire

Apply raised paste scrolls (for gold) all around the top and bottom borders. Use relief enamel tinted with a little pale turquoise to add the 'jewels' inside the dotted circles. Fire at 760°C.

6th Fire

Very carefully, paint over all of the raised paste using burnished gold − covering the paste exactly and not extending into the black groundlay. Paint the gold band around the top of the vase. Fire at 770°C and then burnish the gold.

7th Fire

Using a shade of grey and lavender (mixed) lightly suggest an oriental background scene. Any extra shading can be added to the back of the vase now. Using gold, or coloured raised enamels, decorate the kimono with patterns of your choice. Fire.

Design suitable for: plates, bowls, coffee pots.
Colours used: black, chartreuse, yellow-red, blue-violet, gold-violet.

Japanese Lady Vase

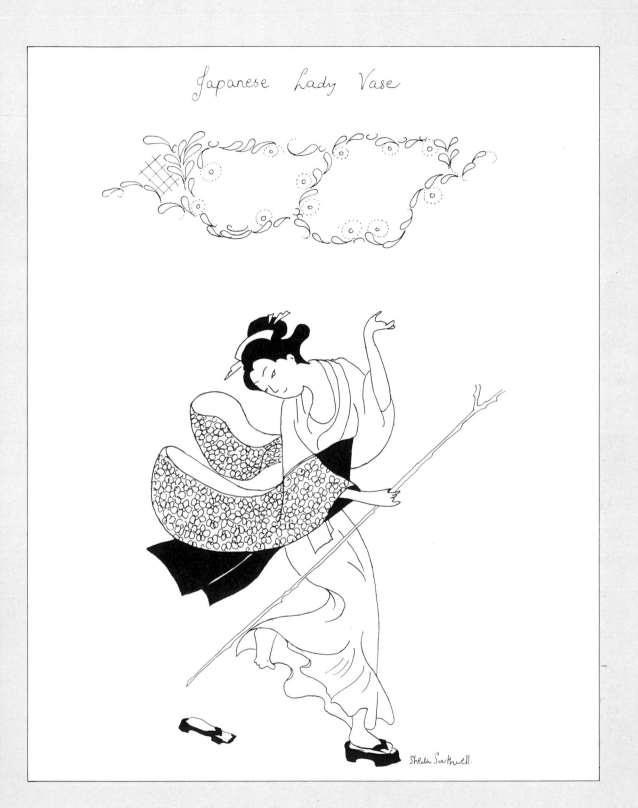

Sheila Southwell.

'I saw the lovely arch of rainbow span the sky
The gold sun burning as the rain swept by
In bright ringed solitude the showery foliage shone
One lovely moment – and the bow was gone.'
Walter de la Mare

Fairy-lustre was a term used in pottery to describe the complex fantasy scenes of fairies and goblins in dreamy woodland settings. This effect was obtained by using different coloured lustres for the main scene, with the fairy outlines done in gold and other precious metals. Usually the negative spaces between the trees and water, etc., were filled with little designs of flowers, bridges and other shapes in gold, giving the whole piece a beautiful and unique look of fairyland fantasy.

The Wedgwood factory in the 1920s produced some of the finest of these and the best were painted by Daisy Makeig-Jones.

My bowl is a very simplified version of fairy-lustre and, providing care is taken to avoid the pitfalls usually associated with lustrework (e.g. not allowing two different wet lustres to touch before firing, etc), it is possible for most china painters to achieve a good result.

It is important to use a good quality bowl as it will need to be fired many times, and bone china will give a better effect with lustres, having a better iridescence than porcelain in my opinion. My bowl just had plain mother-of-pearl on the outside as I was afraid to fire it many more times, but if you paint scenes on the outside as well you will have a lovely piece to treasure.

1st Fire

Trace on the fairy, the leaves and the pendulous branches with a fast-drying pen medium. Very carefully fill in all the design with deepest black, wiping out a few highlights on the flowers and leaves. Wipe out the flower on the fairy's head, and fire at 800°C.

2nd Fire

Go over all the black maintaining the highlights: the figure and tree must be very deep black. Using a very pale outline, pen in the rest of the scene, do not get this too dark as it will be covered first with lustre and then with gold on later fires. Fire at 800°C.

3rd Fire

One wet lustre must not touch another so the scene is painted in sections. Using green lustre, paint the foliage on the trees on the edge of bowl, and also the distant trees. Paint the castle in pale blue lustre. Mask out the flowers, and when dry paint in the hills. With blue lustre paint the water at the bottom. Apply a band of blue lustre to the outside edge of the bowl. Remove masking fluid from flowers, and fire at 760°C.

4th Fire

Paint the trunks of trees with yellow, and also the branches. The road is also painted with yellow lustre. The rainbow is painted using regular china paints with pink, lemon, violet, and green, very pale. Fire at 760°C.

5th Fire

Using emerald lustre paint the foliage on the trees. Paint distant trees with carmine lustre. Paint the flowers with carmine lustre and the leaves with green lustre. Give the water a second coat of blue. Paint a second coat of blue lustre on the outside rim. Fire at 760°C.

6th Fire

Paint the colours on the fairy's wings. Apply a second

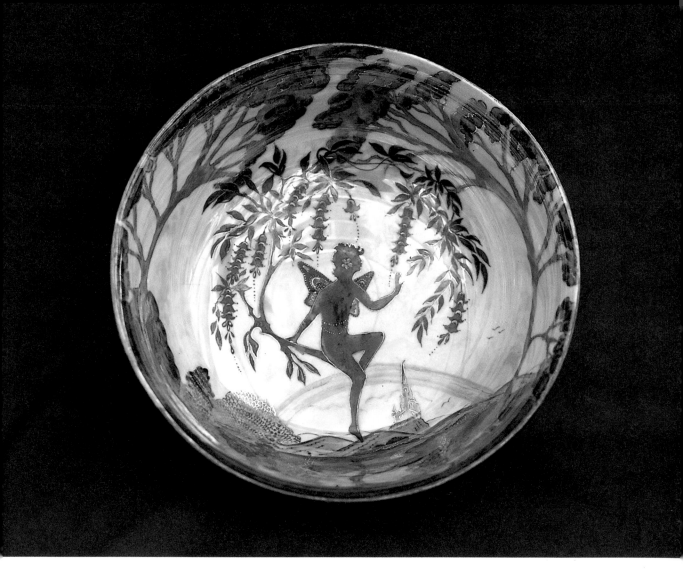

coat of yellow lustre to the tree branches and path, etc. Fire at 760°C.

7th Fire

Adjust any colouring needed on the rainbow and fire.

8th Fire

Apply a coat of mother-of-pearl lustre over the entire bowl. Fire at 760°C.

9th Fire

Using a little white raised enamel and a fine brush, add a few details to the fairy's wings, flower on head, and the pendulous flowers. With a very fine pen and liquid bright gold outline the whole design very carefully doing a little at a time. Paint the flower on the head with scarlet or coral red. Fire at 760°C.

10th Fire

Fill in all the negative spaces on trees etc. with little scrolls, flowers and shapes to give the fantasy effect. Pen some lines on the water and the tree trunk and form a few clouds. Apply a little raised enamel to the red flower on the fairy's head. Fire at 760°C.

Colours used: lustres in emerald, green, blue, mother-of-pearl, yellow, carmine, onglazes coral red, deepest black, pink, violet, green, lemon, white enamel.

Tree Fairy

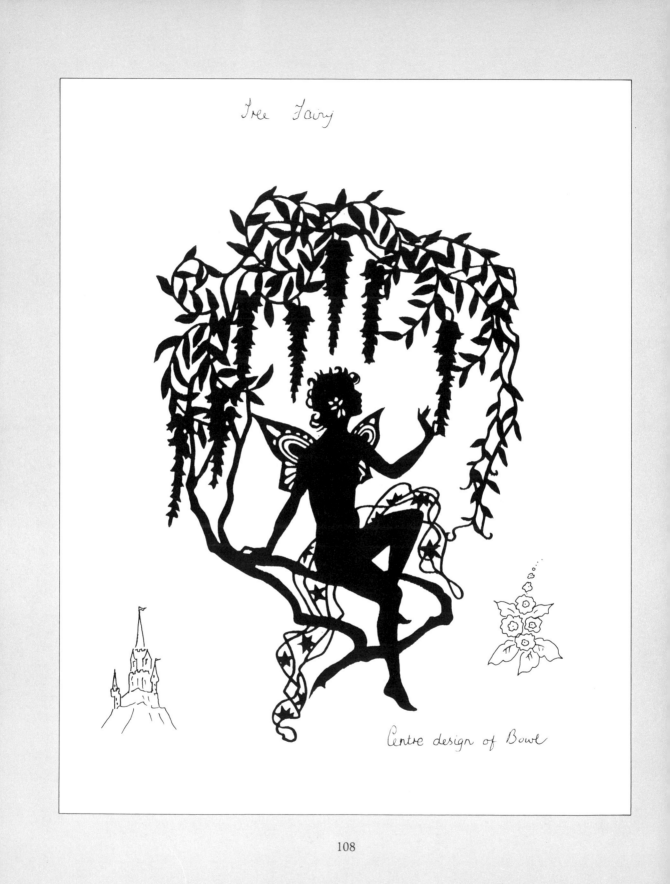

Centre design of Bowl

(Because this design is a difficult one!)
'Life ain't all beer and skittles, and more's the pity,
But what's the odds so long as you're happy?'
G.L.P. Busson de Maurier

For this plate you will need as materials: a bone china plate (a plate with a high glaze is better for this design); onglaze enamel in a dark colour (I used Pompadour); an airbrush, a pretty paper doily, ironed flat. (A supply of tanquillisers is an added aid for this one!)

First clean the plate thoroughly. Press out any uneven or un-perforated portions of the doily: the cut-outs must be absolutely clear and clean-cut, or you will get fuzzy edges. Sieve the onglaze enamel through an extremely fine sieve otherwise the paint particles will clog the airbrush nozzle, or cause splattering. I first used two layers of nylon stocking as a sieve but it is not fine enough and a nylon one purchased from specialist manufacturers is recommended.

Mix the sieved paint with water. You will have to experiment with it to get it just right, so that it is thin enough to go through the airbrush, but thick enough to give an even coverage of colour in one fire as you cannot touch up on subsequent firings. Next stick the doily onto the plate so that it is completely flat to the china, if it is allowed to curl up even a little the sprayed paint will creep underneath the paper and give a smudged edge, (hence the need to iron the doily first). I experimented for two hours with various gums, or with water and various additives before finding that sugared water was best, with just enough sugar to make it slightly tacky. You have to work quickly on the next step as the sugar and water soon dries, and once this happens the doily will start to curl up (in about 4 minutes).

When the doily is in place press out all the surplus water with a tissue (not cotton wool) to eliminate all the air bubbles. Stir the paint and water thoroughly so that no particles are left in the base of the spray cup. With the airbrush held about 12 in from the china, spray over very evenly several times, making sure that you have completely covered both the plate and the doily. Allow to dry for a minute and give another spray over. As the paint is mixed with water only, it will dry quickly and have a powdered look to it. *Clean out the airbrush immediately.* When the paint looks dry (the doily may be getting dry, so don't leave it long enough to start curling up) *gently* lift the doily from the plate with a needle point being careful not to splatter the paint over the bits which are meant to be white. You will be delighted with what you see, especially if you use a very dark colour. If the paint has spread just a tiny bit you can clean out with a little cotton wool on a toothpick (no turps). If you find you have smudged the design it's impossible to repair this and you will have to wipe it off and start again – this is where you take your first tranquilliser!! When the piece is fired (give it a hot fire, about 800°C) you can if you want edge some of the design with gold penwork, and I have added Dresden flowers, forget-me-nots and baby roses in the spaces.

If you don't have an airbrush this effect can be achieved by using a groundlaying technique over the doily, the oil being padded over both the doily and the plate. When using any groundlaying technique be sure to observe the safety regulations. I don't recommend this technique to beginners.

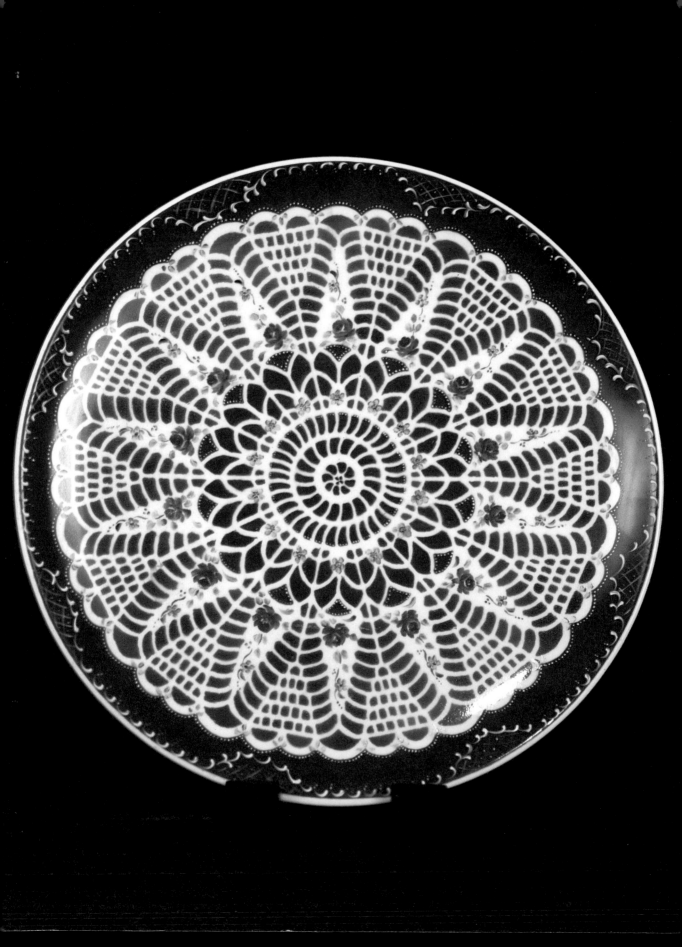

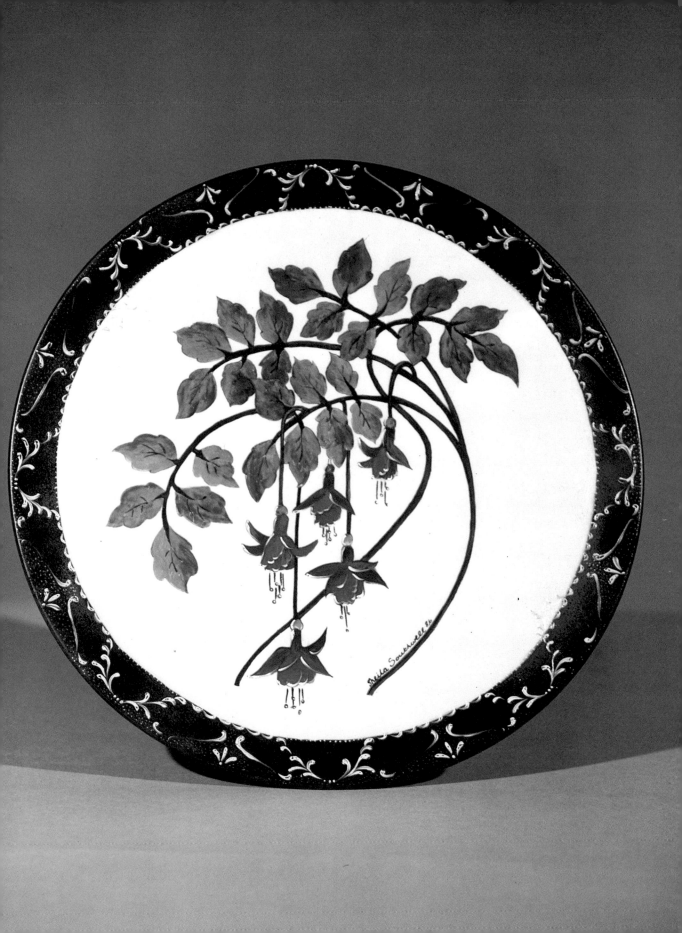

'How doth the little busy bee
Improve each shining hour,
And gather honey all the day
From every opening flower!'
Isaac Watts

'Art nouveau' was a term used by Samuel Bing in 1885 to describe decorative art objects for sale in his Paris shop. It was a 'new' art form, consisting of stylised patterns with curving lines and flower designs, often including beautiful women, with long flowing hair, who were incorporated into some of the designs. This style of decoration was applied to all the decorative art of the period which started about 1880 and which had ended by 1912 and was followed by a less romantic period known as 'art deco'. Art nouveau designs are particularly well suited to the decoration of porcelain, especially tall vases, etc., where the graceful curves can be seen to their full advantage. Famous artists of the period were Mucha Charpentier, and Lalique the jeweller and glass-maker.

For full instructions on applying lustres and raised enamels please refer to pages 28 and 29.

1st Fire

Trace the design carefully onto the china, making sure it is correctly placed on the plate. Outline the design with a fine pen. Using black onglaze enamel and a fine scroller brush, paint in all the stems in dense black, forming the little points in the leaf section. With black lustre paint the outside band of plate. Fire at 770°C.

2nd Fire

With green lustre paint all the leaves, keeping the strokes as smooth as possible. Paint the flowers with carmine-pink lustre. Paint the edge of plate again with black lustre. Fire at 770°C.

3rd Fire

Paint the leaves and flowers again, using the same colours. Fire at 770°C.

4th Fire

Apply a coat of mother-of-pearl lustre over the entire plate. Fire 770°C.

5th Fire

Mix some relief enamel, adding a little pale pink to it, and bearing in mind that it will fire a slightly darker pink. With a fine brush apply the enamel highlights to the petals and then add the scrolls to the border panel. With a fine pen and bright gold, form all the little dots between the scrolls around the edge of the plate. Fire at 760°C.

Colours used: lustres: black, carmine, green; onglaze: black, pink.

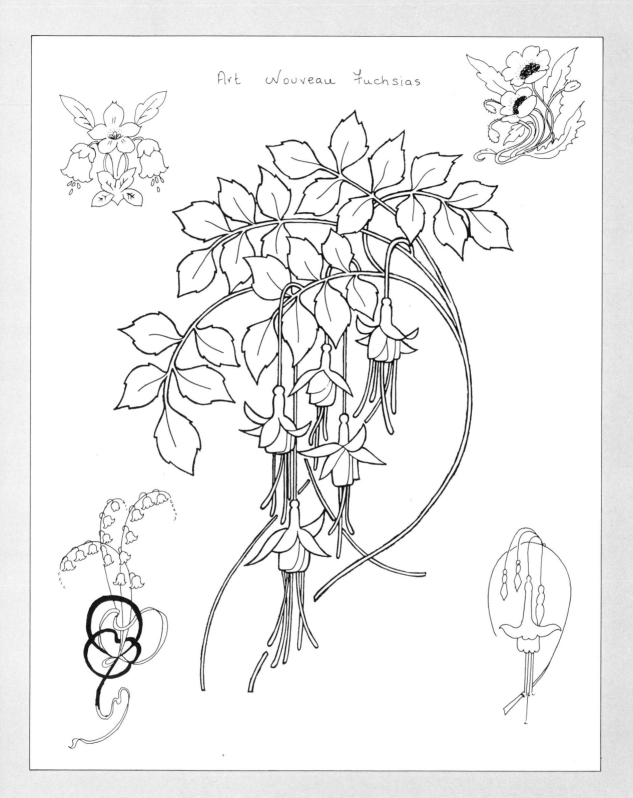

Art Nouveau Fuchsias

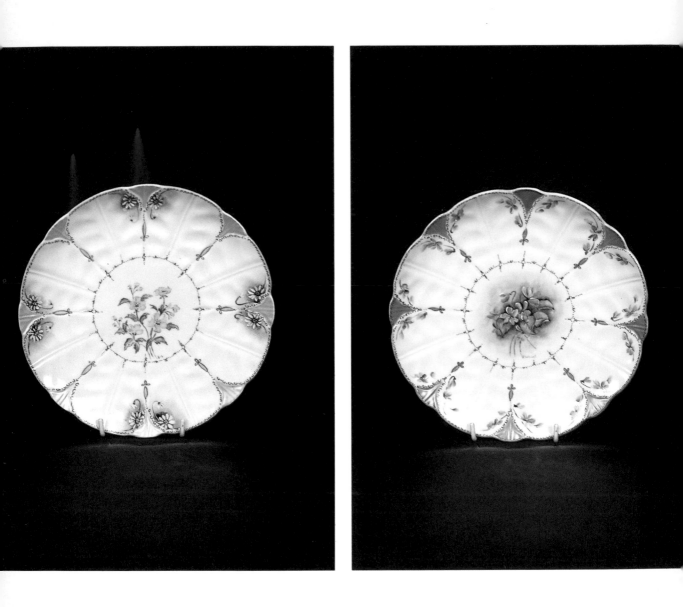

Violets & Daisies

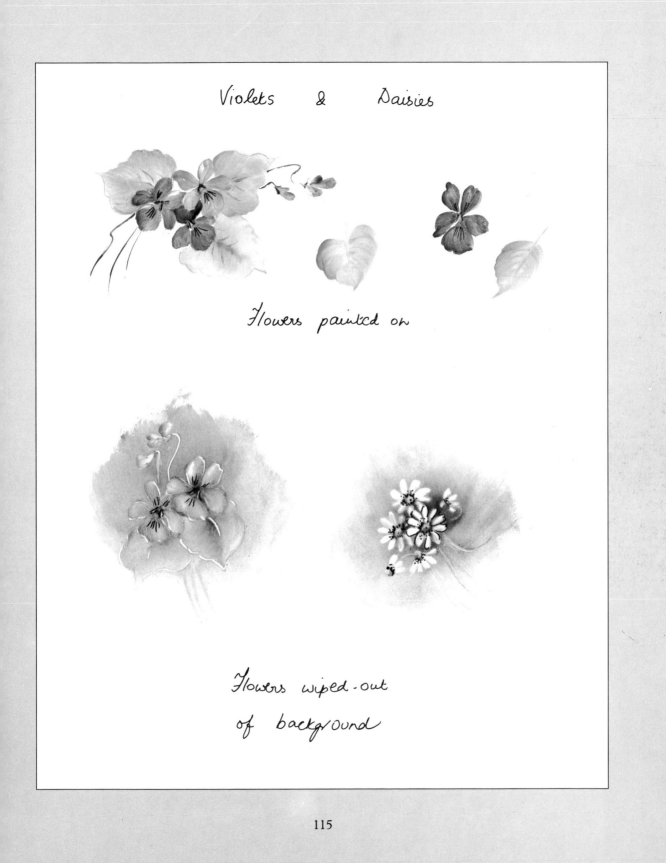

Flowers painted on

Flowers wiped-out
of background

'You will find a thousand valleys there of many shades of green
And fields of yellow buttercups and daisies in between
The hawthorn blossoms sweetly and the orchard trees are gay
The elder grove's a picture in the lovely month of May.'

A.J. Lancefield

This is a lovely idea for a matching pair of plates in tasteful colours.

Both of these plates were done in the same way, with the metallic groundlaying being done first. One plate had English wild violets and the other English buttercups and daisies.

1st Fire

Cover the areas to be groundlaid with groundlaying oil and lightly pad with silk, then with a brush cleaned in turps, clean back the edges so that the oil is only on the area to be groundlaid. It is a good idea to tint the oil with a little colour so that you can see where you have painted it. Using a large soft blending brush, pick up a little of the metallic colour and proceed to cover the oiled areas; you will find that the metallic colour covers very well, although if you have any area which does not have sufficient oil to hold the colour you must wipe it off and start again. Fire at 820°C.

2nd Fire

Paint the centre panel with your design and then paint all the little flowers around the edges of the plate. Fire at 780°C.

3rd Fire

Add any shading to the central design and then using fine pen and grey/black colour, pen the little scrolled design around the central panel. Shade the design around the edges of plate and then with pen draw the scrolls around the groundlaid edges. Fire at 780°C.

4th Fire

Add a little white enamel to the edges of petals and fire at 780°C.

'And tis my faith that every flower
Enjoys the air it breathes.'
William Wordsworth

The hibiscus is a very exotic flower which I first saw growing when I lived in Australia, and in the garden there we had several species in the most gorgeous colours. I now grow them in my greenhouse and this one was painted whilst in flower last summer. I noticed particularly that the petals always seem to overlap in the same way. The large pistil is covered with tiny pollen sacs and has four enlarged ones at the top. I use ES Colours yellow-red No. 22 as it mixes well with any colour including yellow and shades with blood red beautifully.

1st Fire

Sketch on the design. Paint in the background using black grape, yellow and pale turquoise, filtering the colours together. With No. 5 square shader, paint the leaves with yellow, wiping out a few highlights. With yellow-red, paint the large petals starting with the flower underneath: leave an area on the centre of each petal and paint this with yellow, then blend the two colours together, and wipe out one or two turn-backs on petals. Wipe out the stamens with a toothpick or tool, and paint the pistil yellow-green. Fire at 820°C.

2nd Fire

Deepen the background using black grape and ruby on the bottom of design, and yellow-brown and medium green elsewhere, leaving some little 'windows' of the original background colour showing through. Shade the leaves with autumn green in the shadow areas and on the buds and paint the red on the buds. Apply more yellow-red to the flowers, maintaining the yellow highlights and turn-backs. Paint the pistil with yellow-brown and green. Paint the stems. Wipe out the stamens again. Fire at 800°C.

3rd Fire

Make the background really dark under the design with ruby and black grape. Adjust any more shading at this stage.

4th Fire

Needed to make background darker only.

5th Fire

Add a little white enamel to the stamens. Fire at 760°C.

Colours used: yellow-red, yellow-brown, ruby, black grape, yellow-green, autumn green, turquoise, Albert yellow, brown.

Hibiscus Flowers

Sheila Southwell

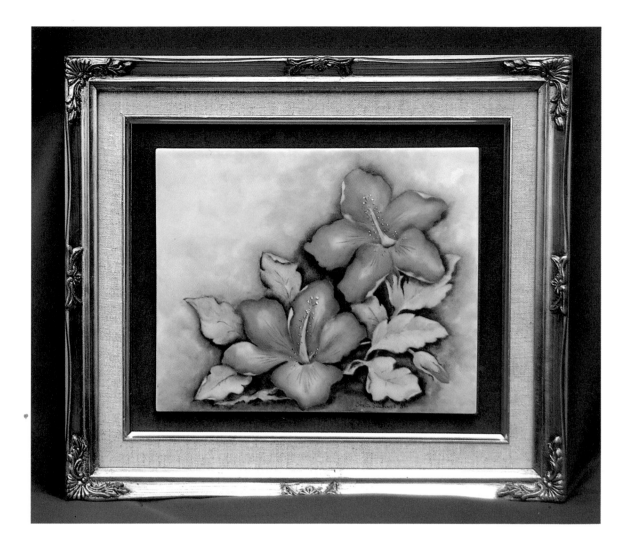

'Buy my English posies
You that will not turn
Buy my hot-wood clematis, buy a frond o' fern
Gathered where the Erskie leaps
Down the road to Lorne
Buy my Christmas creeper and I'll say where you were born.'
R. Balfour

CLEMATIS PLATE

The clematis flowers come in a variety of colours, including white-blue, violet and purple, and there is also a small yellow variety. One of the characteristics of the clematis is the way in which the tendrils trail and curl around the stems and up their supports. These give an airy appearance when used on our designs on porcelain and lend themselves admirably to art nouveau designs. The centres are very prominent on most varieties and consist of furry stamens clustered together which are sometimes quite long. Often there is a pale stripe along the centre of each petal.

1st Fire

Sketch the design onto the plate and apply the background colours first, using shades of lemon, lilac and blue with a little pink for warmth. Paint the leaves with leaf green keeping them light and leaving one or two highlights. Paint the flowers with blue-violet, lilac, baby blue, and royal purple. Wipe out a central vein on each flower. Fire at 820°C.

2nd Fire

With black grape, maroon and dark green add some more background and filter in some yellow-brown here and there to give it warmth, tucking the background well under the flowers. Shade the leaves with moss green, leaving the highlights, and paint the stems. Paint the centres with lemon shaded with yellow-brown. Use blue, violet and royal purple to paint the flowers, and make the darkest one glow with

a little American Beauty, wiping out that central vein again. With blue-violet paint the edge of the plate and smooth with silk over your finger. Fire at 820°C.

3rd Fire

Deepen colours where necessary and paint in the curly tendrils on this fire. Deepen the edging with blue violet. Fire at 780°C.

4th Fire

Add the centres with enamel with a bit of yellow added. Apply old scrolls with burnishing gold and fire at 770°C.

CLEMATIS JUG

This jug was so lovely just plain white with its curving handle that I was hard pressed to know what to paint on it at first, but decided that the smaller clematis would look pretty and designed it so that the flowers followed the line of the handle. The handle was given two coats of burnishing gold.

1st Fire

Trace the design on, allowing it to curve around the jug or vase. Using yellow-green lay in a background around the design, blending in a little blue-violet here and there but keeping it very light. Paint the wavy petals with sky blue and violet, and the leaves with yellow-green, shaded with a little olive green and ochre. Wipe out a centre vein on each petal and fire at 820°C.

Clematis

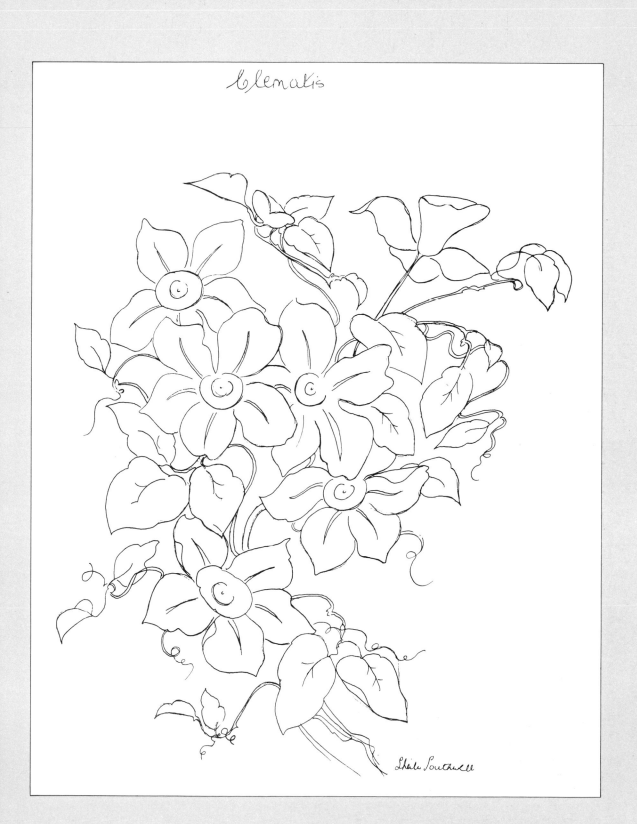

Sheila Southwell

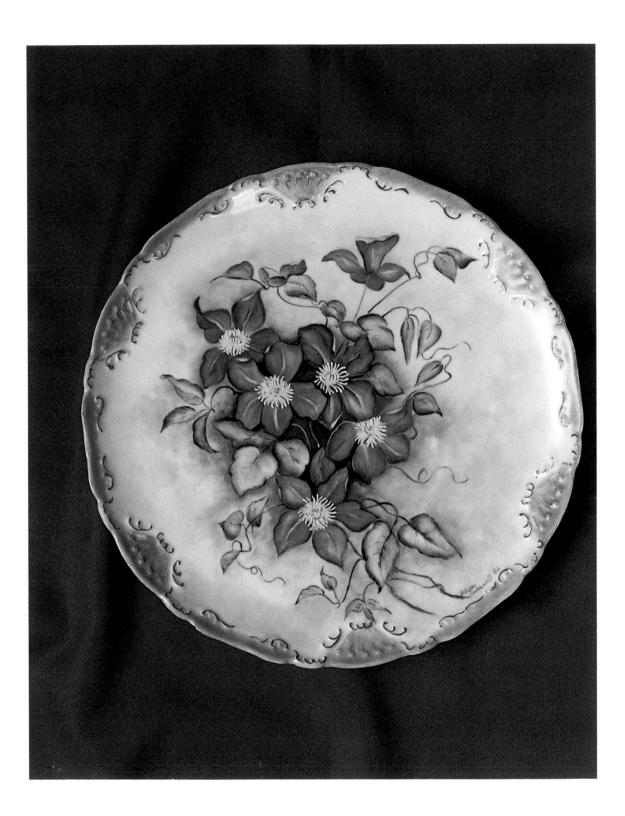

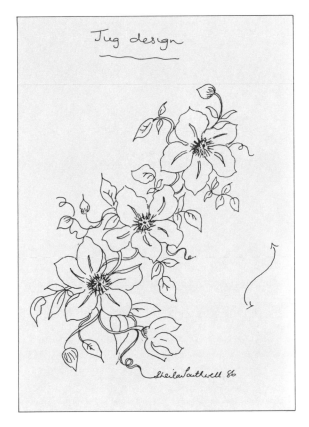

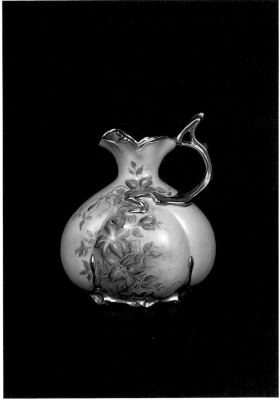

2nd Fire

Deepen all the colours and paint in the curving tendrils. Paint the centres yellow. Fire at 820°C.

3rd Fire

Apply a little white enamel to the petals and stamens. Paint the gold on the handle and fire at 770°C. A small complimentary design was painted on the reverse side on this fire.

4th Fire

Complete the design on the back and paint the handle again with burnishing gold. Fire at 770°C. Burnish the gold after firing.

'He stands alone and proud on hillside high,
His broad fierce antlers etched on azure sky;
His fierce stance defies all men,
He is the Monarch of the Glen.'
Sheila Southwell

1st Fire

Draw the stag, paying particular attention to the face and the eye, which should be drawn in detail. Roughly sketch in the background scene, merely blocking it in at this stage as most detail will be done with the brush. With malachite blue filter some colour over the sky, shading it with a little lemon and grey. Wipe out some clouds with silk over your finger and blend with a soft brush. The distant mountains are painted with blue-violet dulled with grey, keeping the colouring light at this stage. Paint the antlers with pale grey and violet. Paint the eye of the stag next and make sure it is absolutely correct before proceeding further, not forgetting the white highlight on the eye pupil. For the first fire on the stag I use red-brown and a little yellow-red in the lightest parts; the black part is painted at this stage with purple and grey. After painting the yellow red I paint a little yellow with it, wet-in-wet. The body is painted with a soft flat no. 4 shader. I use only enough colour on this fire to establish the shape and contours of the body. Paint a wash of yellow-green over the foreground, wipe out the rock with your finger, and blend the colour with a brush. I use a fine pen for the leaf border around the edge done on this fire using black. Fire at 800°C.

2nd Fire

I worked on the scenic background only and added more colour to the sky and distant mountains. Shade the sky with malachite with a tiny bit of grey, and add a yellow glow on the right side behind the mountains. Paint the mountains on this fire with violet dulled with grey and with a little celestial blue, very light, wipe out the crags and undulations with your finger and soften with a brush. The two birds in the sky were not originally intended, but on the last but one fire a black mark appeared after firing – fortunately it was in a spot which could be covered, hence the two birds. The foreground was shaded with olive and autumn green and grasses were wiped out using the edge of a flat shader. The heather was blocked in with ruby, suggesting little clumps. The rock was shaded with ruby and green and grey.

3rd, 4th and 5th Fire

These fires were all used to work solely on the stag. Each time I worked on the face first, paying particular attention to the expression and the eye, and the areas around them. The antlers were shaded with grey and mid-brown, leaving highlights here and there. The ears were done with salmon pink and the hair with brown and beige, as they are very light on the undersides. The colouring on the coat was gradually added, with shades of yellow-brown, hair brown, yellow-red, blood red and grey and black, the black being reserved till the last firing. Make sure the area under his ruff is lighter than the chest area. Allow some of the yellow-brown from the earlier fires to show through, as well as a little yellow-red. A tiny touch of white enamel completed the eye.

6th and 7th Fire

I used these fires to add the colouring to the leaf border.

Colours used: malachite blue, baby blue, yellow, grey, violet, yellow-red, blood red, hair brown, mid-brown, purple, black, yellow-green, olive green, ruby, a touch of white enamel for the highlight on the eye, American Beauty.

124

The Monarch of the Glen.

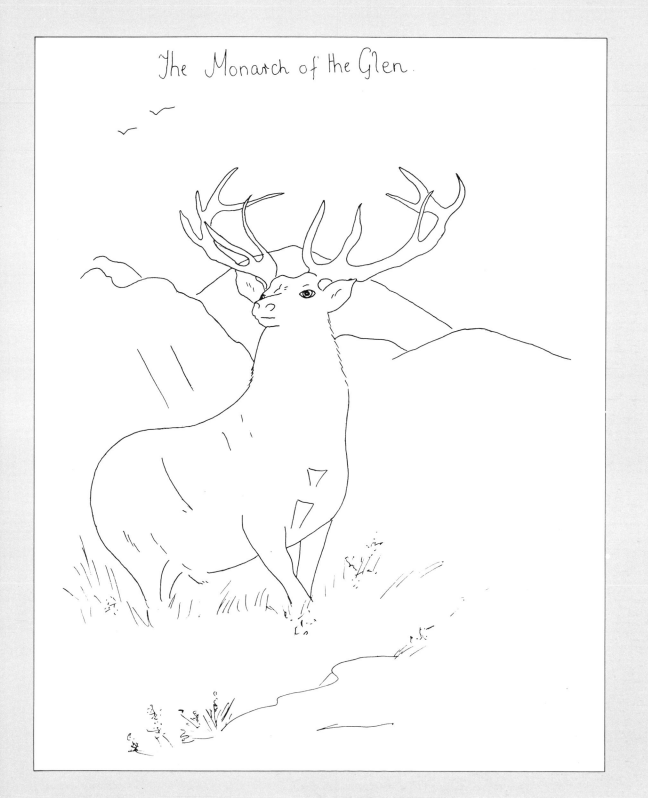

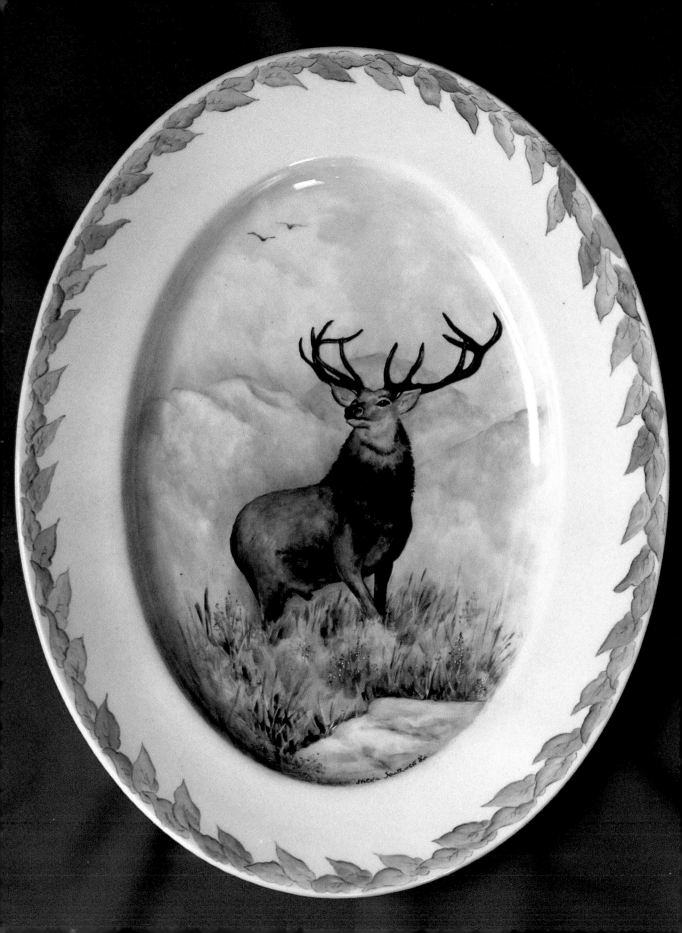

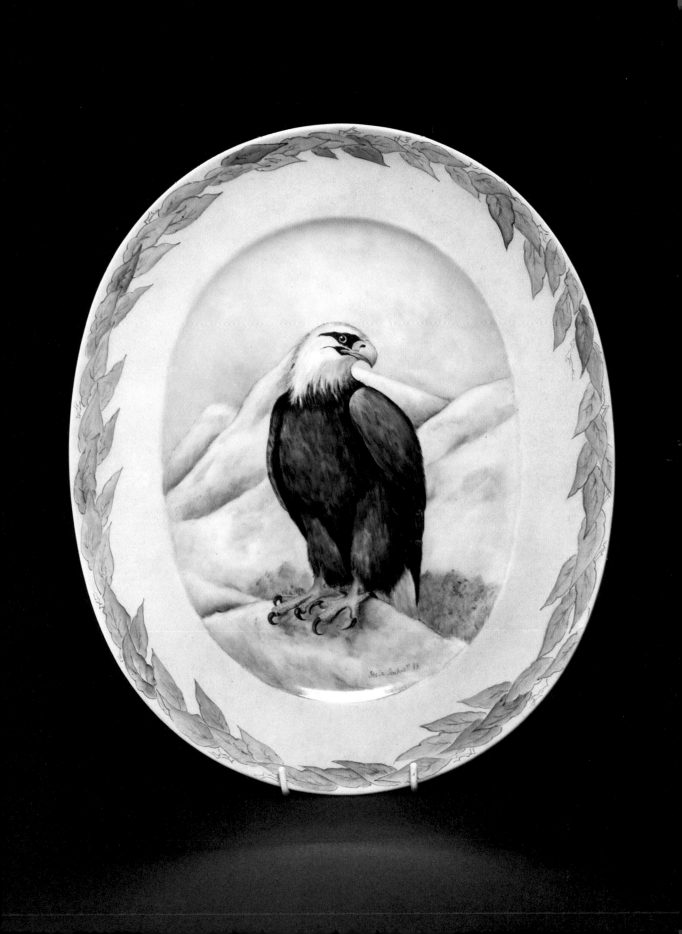

'He clasps the crag with crooked hands;
Close to the sun in lonely lands,
Ring'd with the azure world, he stands.
The wrinkled sea beneath him crawls;
He watches from his mountain walls,
And like a thunderbolt he falls.'

Tennyson

1st Fire

Sketch or trace on the eagle and roughly block in the scene, paying particular attention to the eye and beak. Using malachite blue, grey and a little pink and lemon, paint in the sky, so as to look cold and wintry. Wipe out a few highlights here and there with finger and blend with a brush. Paint the shadow areas of the mountains with pale grey and violet. Suggest the trees in the valley with autumn green. Paint the rock with grey, green and a touch of blue. Very lightly paint the eagle using soft grey, just sufficient to maintain shape and contours. Paint the eye in detail, highlighting the pupil. Paint the beak with yellow and yellow brown. Fire at 800°C.

2nd Fire

Work only on the background and border, which is penned in using brown for the leaf shapes. Paint the sky with grey and violet mixed together, leaving a little of the pink and yellow showing from first fire. Shade the mountains with similar colours marking the contours with your finger and blending smooth. Add a little more colour to the trees in the valley and to the rock shading under the eagle's feet. Fire at 820°C.

3rd Fire

Working on the eagle only, paint the head with soft grey and with a fine brush which is 'splayed out' pull the feathers down onto the chest area. Paint the dark area around the eye with very dark brown, and also the dark part around the mouth. Complete the beak on this fire with yellow-brown and yellow. Paint the body of bird with yellow-brown and golden yellow, shading the part under the wings and between legs with light brown. Paint the bird's legs and claws with yellow brown. Fire at 820°C.

4th Fire

Add shading to eagle's head and body using blue-grey on the chin area and mid-brown on the body. Paint the brown on with a flat brush and blend into the shadowy areas under wings and legs. Allow plenty of the undercolour to show through on this fire. Paint the claws with black grey. Fire at 820°C.

5th and 6th Fires

Complete the bird's feathers using dark brown with a little black in the darkest parts. The golden yellow should be allowed to show through on the lightest parts and the little criss-cross marks on the chest wiped out. Adjust any further shading on this fire and complete the border design. Fire at 800°C. Place a touch of white enamel on the eye.

Colours used: Grey, malachite, pink, lemon, yellow, golden yellow, yellow-brown, green, dark brown, black, white enamel on the eye highlight.

King of the Mountains

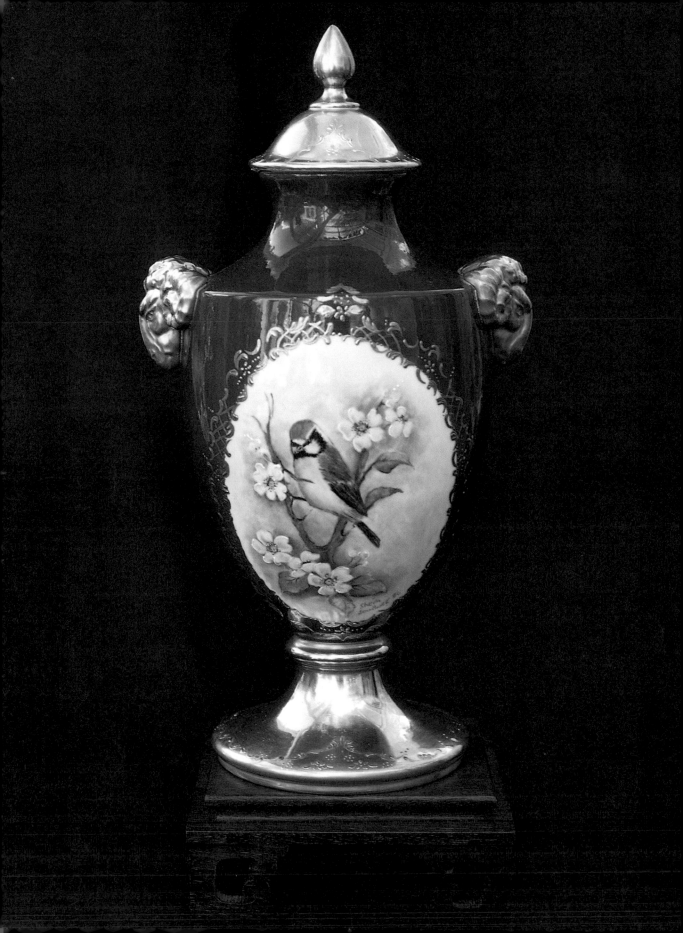

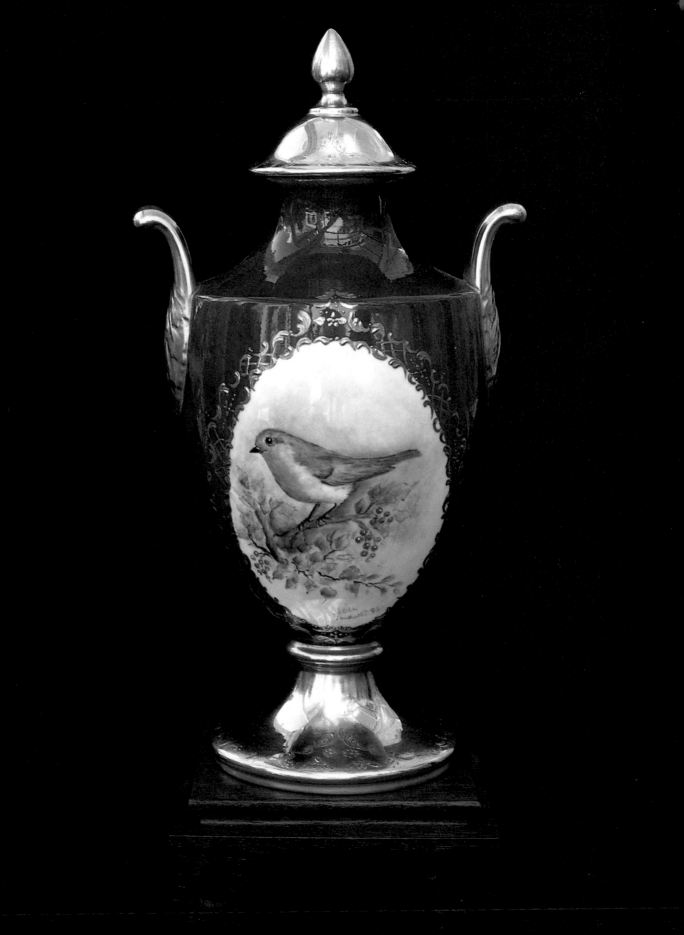

'In the sedge a tiny song
Wells and trills the whole day long;
In my heart another bird
Has its music heard.'
Walter de la Mare

These bone china vases were expensive and needed special treatment. After much deliberation I decided on two of our most popular English garden birds: the blue-tit and the robin. Groundlaying was used for the main part of the vases with raised paste and burnishing gold around the reserved panels. When selecting your porcelain and china for this type of work only the best will do, and I chose good quality English bone china. The same techniques were used for both vases and I worked on the two simultaneously.

1st Fire

Mask off the reserved panels and the handles and groundlay with deep red. I used Garnet red for these. Remove the masking fluid before firing, and fire at 800°C.

2nd Fire

Sketch and paint the birds paying particular attention to the faces and eyes. Use a No. 3 brush with the hairs 'splayed out' which gives little fluffy feather strokes. Fire at 800°C.

3rd Fire

Used to complete the birds.

4th Fire

Add any more detail on the birds and then add the raised paste design very carefully. Fire at 770°C.

5th Fire

Completely cover the raised paste with burnishing gold. Fire at 770°C.

6th Fire

Apply another layer of gold and do the lids. Fire at 770°C. Burnish all gold after firing.

Colours used: garnet red, yellow-red, yellow-green, olive green, lemon, yellow-brown, black, Albert yellow, grey.

Blue-tit & Robin

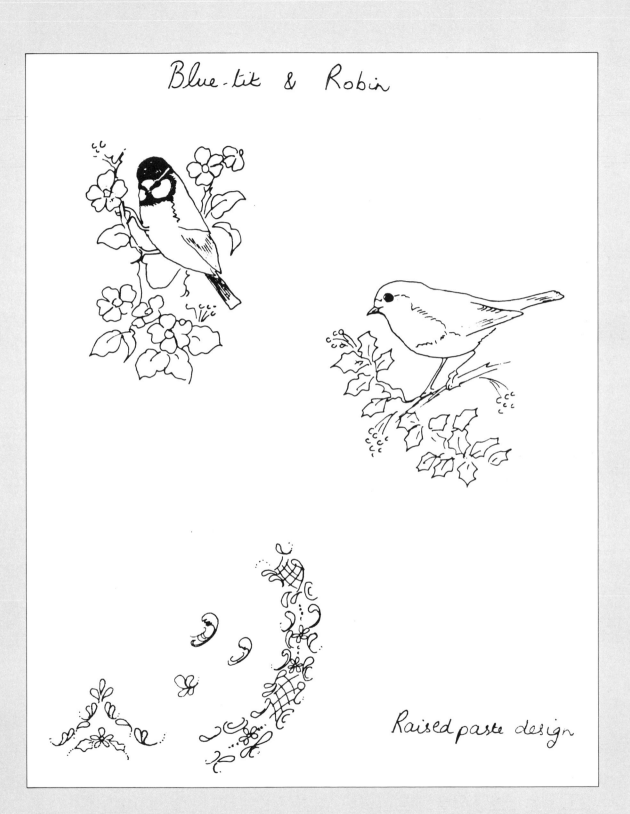

Raised paste design

Part 3
USEFUL INFORMATION

Glossary of china painting terms

The following glossary is a compilation of terms which it has taken me several years to accumulate and consists of terms which are often confusing to the china painter, especially the beginner. On hearing a word or a phrase which I didn't understand I jotted it down and later looked up the meaning and made note of it. Here you have the culmination of my efforts and I hope you will use it to the full if you hear or read something that you are not sure of.

ACID ETCHING
A method of removing the glaze with hydrofluoric acid, for use with gold, which gives a two-tone gold effect.

ACID RESIST
Asphalt which is painted over the portion of the design not to be removed with acid — this area is later painted with gold. A very dangerous undertaking if not done with complete safety precautions.

AGATE ETCHING
A safer method of obtaining a similar effect to acid etching but done with an agate stone. The stone scratches through an area of burnished gold showing a shinier bright gold underneath.

AIRBRUSHING
A method of applying a smooth layer of colour through the fine needle of an airbrush that is an alternative to groundlaying.

ALCOHOL
Pure spirit used to clean china prior to painting, not available in the UK. Genklene is an excellent alternative, which evaporates immediately on exposure to air, and is particularly good for cleaning dirty brushes.

ALLERGY
Some people develop an allergy to turpentine; Limidex is an alternative, also lavender oil or Grumtine.

ANTIMONY
A mineral used in the manufacture of enamel colours, mainly the yellows.

ANTIQUES
Name given to pieces at least 100 years old.

AQUA REGIA
Powerful acid, once used to dissolve gold for the use of china decoration.

ARABESQUES
Intricate surface decorations based on rhythmic patterns of scrolling and interlaced foliage etc. Human figures are not used in this style of decoration; these are called 'Grotesques'.

ARMORIAL DESIGNS
Coat of arms.

ART DECO
Fashionable art form between 1918 and 1939 which

consisted of modernistic zig-zag geometric designs such as triangles etc., using lots of colour, following the art nouveau period.

ART NOUVEAU

'New' decorative style which originated in the 1880s and reached the height of its popularity around 1900. Designs were characterised by the use of trailing tendrils and flowing lines, flowers and leaves. Motifs often featured the female form with masses of flowing hair.

ARTIFICIAL PORCELAIN

An early imitation of hard paste porcelain made from white clay and glass.

ARTISTS IN ANTIQUE PORCELAIN (some of the most famous)

Franz Bischoff, Aulich, 'Quaker' Pegg, Wm. Billingsley, Marc Louis Solon, Harry Davis, John Stinton, Wm. Duesbury, R.F. Perling, James Rouse, Thomas Baxter, Percy Curnock, J.C. Noke. If you own a piece painted by any of these you are indeed lucky.

BACKGROUNDS

The negative space around the main design. If painted, it is done with a flat shader brush.

BACKSTAMPS

The name of the factory or artist on the back of a piece, usually applied by transfer or incised in clay.

BADGER BLENDER

Large fluffy brush made with badger hair and used for blending background colours together.

BALSAM OF COPAIBA

Medium used for china painting made from the gum of a tree.

BANDING WHEEL

Turntable used for applying fine bands of colour around plates and cups, etc. The piece is centrally situated on the turntable and gently rotated whilst the artist applies the special brush loaded with colour to the piece. The line should be smooth and not ragged and takes a lot of practice to achieve, easy after the first 2,000!

BAT

Name for the kiln shelf.

BAT WASH

Special powder purchased to be mixed with water and painted onto the kiln shelves to prevent wares from sticking.

BCPAA

British China & Porcelain Artists Association, non-profit-making organisation based in England (for details of Organisations see page 152). An organisation evolved to help further the art of china painting, which has an Annual Convention each year.

BELLEEK

Porcelain factory founded in Ireland in 1857 whose wares have a lustrous pearly appearance.

BERLIN STYLE

After the style of painting at the Berlin factory in Germany. The designs consist of the artists' own stylised interpretation of flowers, leaves, and birds, etc. These are not specific varieties but are unmistakably flowers, leaves and birds, often with a fine pen outline.

BILLINGSLEY ROSES

The roses painted by William Billingsley who worked at the Derby factory and later at Worcester and Coalport. He specialised in the 'wipe out' technique in flower painting.

BISQUE

The china or porcelain in its 'biscuit' state before the glaze application: pottery is often decorated at this stage but china and porcelain are decorated after the glaze has been fired.

BITUMEN

Another name for asphalt.

BLANC DE CHINE

Blank white china.

BLANK CHINA

As above.

BLENDING

Softening of the brush strokes with a fluffy blending brush.

BLENDING BRUSH
See above.

BLENDING AND SOFTENING
Using the above brush to give a softer appearance to the background.

BLISTERING
Appearance of a piece which has a damaged blistered glaze, caused by a fault in glost firing. Sometimes called 'spitting'.

BLUE DELFT
See Delft.

BOCAGE
Modelled leaves and flowers often made into a support for a figurine.

BONE CHINA
Translucent intensely white ware with lovely glaze. When held to the light is possible to see the shape of a hand through it. Made from 50 per cent animal bone, 25 per cent china stone, 25 per cent china clay. Ingredients melt and fuse together giving a very hard strong body. Its secret is attributed to Josiah Spode, who found that by adding bone ash to the clay mixture a white translucent ware was produced. Biscuit firing is done at 1200°C approx. Glost firing at 1100°C approx. and decorating firing 760-800°C. Because bone is expensive to use substitutes have been made, but true whiteness is never achieved without it. Sometimes bodies which have been stained with metal oxides give a creamy or grey shading and look like porcelain.

BONE HORN PALETTE KNIFE
Sometimes used to grind colours, but can contaminate the gold colours.

BRIGHT GOLD
Liquid bright gold, a gold used for decorating china and porcelain which is made from varying qualities of gold, and you get what you pay for. After firing it has a bright appearance on removal from the kiln.

BRITISH CHINA PAINTER
Official magazine of the BCPAA.

BRUSH STROKES
The many different shapes that can be made by using the brush in various positions.

BUGS AND BUTTERFLIES
Little insects which were painted over flaws in the china years ago, and can be seen on Continental porcelain most often – a little trick we still adopt today.

BUNG (VENT)
The plug of ceramic material which is inserted into the hole in the kiln to seal it after all noxious gases have escaped.

BURNISH
To burnish – the act of polishing the gold after firing.

BURNISHING BRUSH
Glass fibre brush used to get into awkward places when burnishing (beware of getting these fibres into the skin).

BURNISHING GOLD
Another name for the 22 ct gold used on prestige pieces, which needs polishing after firing to assume its beautiful patina.

BURNISHING SAND
Fine sand used to polish gold after firing.

CABARET
Name given by collectors to a small teaset on a matching porcelain tray.

CADMIUM
Mineral oxide used in enamel colours. Cadmium selenium colours cannot be mixed with other colours.

CAMOUFLAGE
Small faults can be 'hidden' by painting flowers or insects over them; sometimes raised enamel can be used in the same way.

CARTOUCHE
Ornamental panel in the form of a scroll, often with an inscription.

CASING
The thick lining walls of the kiln.

CASTELLATED PROPS

The ceramic shelf supports in the kiln, so called because they are shaped like castle turrets.

CELADON

Type of Chinese stoneware or porcelain with characteristic olive green glaze derived from iron oxide, probably derived from the character Celadon in a seventeenth century pastoral who wore grey-green ribbons.

CERAMICS

A nineteenth century term covering all types of pottery and porcelain, said to come from Greek word 'keramos', meaning vessel of clay.

CHARCOAL PAPER

Paper with charcoal backing used for tracing.

CHINA

General term used to describe the wares on which we paint because China was the first country to make such material. See more detailed description under Bone China and Porcelain.

CHINA DECORATOR

American magazine for china painters.

CHINA DECORATOR

Name in the industry for a person who decorates the ware.

CHINAGRAPH PENCIL

Special soft pencil used on porcelain.

CHINA PAINTS

The onglaze enamels used on china.

CHINA STONE

Important ingredient in the manufacture of china and porcelain.

CHIPPING

Colour or enamel which chips off surface after firing, lifting the glaze too; repaint the area adding a little flux to your colour.

CHOP PLATE

American term used to describe large plate.

CHROME

Mineral oxide used in the manufacture of enamel colours, mostly greens.

CLAY

Name of the material used to make china, porcelain and pottery whilst still in its natural state, before firing.

CLEANLINESS

Most important for a china painter to produce well executed work: if your palette and work area is dirty, then so will your painting be.

CLOISONNE

The art of forming 'cloisons' or cloistered enclosures using delicate metal strands to form patterns which are then filled with colourful enamels, which originated in Byzantium but was perfected by the Chinese over 1,000 years ago.

CLOVES, OIL OF

Ethereal oil used to delay drying process when mixing colours.

COBALT

Imported blue metal oxide, prepared from cobalt oxide discovered in Saxony in 1545 and used in the decoration of early porcelain and Delftware as chief source of decoration.

COLD COLOURS

Term used to describe shades of greens and blues, etc.

COLOURS

Useful pigments for ceramic decoration made from refined mineral oxides. Specific names given to some colours are often confusing as each manufacturer names his own and you will often find the same colour described by different names to make it sound more attractive to the china painter. Many are named after colours used by the Meissen and Sèvres factories, particularly those used by the factories for groundlaying as they are a similar colour. Some of the most popularly used ones I will mention here: *Gros de bleu* – a deep blue as used at Sèvres; Celestial blue – a lighter shade of sky blue; Pompadour – a deep red-brown colour; *Jaune jonquille* – a soft yellow, as used by Sèvres; Mazarine – rich royal blue; American beauty – lovely damson purple; Albert yellow – bright clear yellow; Copen blue – blue grey; Violet of iron – a deep iron pigmented red-

brown colour; Water green – soft pale green with blue tones; Chartreuse – lime green; Trenton ivory – a soft pale creamy yellow.

COLOUR WHEEL
Colour guide used by artists showing primary, secondary, and complimentary colours and tones, and their relation to each other.

COMPLIMENTARY COLOURS
Those opposite on the colour wheel.

COMPOSITION
The art of making the design into a pleasing whole.

CONDITIONING THE BRUSH
Method of impregnating the hairs of the brush with oil to help the colour to flow more smoothly, of primary importance to good painting. The brush is 'wiggled' in a small quantity of oil, allowing it to penetrate into the hairs up to the ferrule.

CONES
Small ceramic shapes, usually triangular, designed to melt at a pre-set required temperature, and which always give an accurate reading.

COPAIBA BALSAM
Popular china-painting medium which if used alone gives a medium which dries fairly quickly, oil of lavender or cloves can be added to allow more painting time.

COPPER
Pure metallic oxide which gives a perfect copper effect when fired.

CORNER LOADING THE BRUSH
The method of dipping the flat shader brush into the colour so that only one side of it picks up the paint, often used with the naturalistic style of painting.

COTTON WOOL BALL
Small pad of cotton wool covered with layer of silk to allow the colours to be padded to give softer effect.

COUPE PLATE
Plate without a rim, much loved by china painters.

COVERCOAT
Plasticised material used to cover design when making transfers or decals.

CRACK THE KILN
Leave it open a few inches.

CRAQUELLE OR CRACKLE
The method of crackling the glaze when firing: gold can give effective results.

CRAZING
Network of thin lines in the glaze resembling fine cracks, caused by a fault in glazing process.

CROSS HATCHING
Method of painting brush strokes in different directions over each other, when painting backgrounds.

DECALS
Another name for transfers made by printing or painting a design on a paper backing, and covering it with protective film. The paper backing is removed before firing and the film fires away leaving the design permanently on the china, a process used in the china industry to enable thousands of pieces to be decorated relatively quickly so that all look identical.

DEEPEN THE COLOURS
Simply paint another layer of colour to give deeper tone.

DELFT
Town near Rotterdam in Holland noted for its blue and white faience (tin glazed earthenware) – not the first to make this but the most famous. The name Delft was given to other wares besides the Dutch and it was made in England for a number of years and also in Germany, but to avoid confusion the wares made in Delft were called Dutch Delft and often show rural Dutch scenes with ships and windmills.

DENATURED ALCOHOL
Pure spirit used for cleaning brushes and china, not available to buy in the UK. Genklene is an alternative.

DESIGN
To formulate an original idea and transpose it onto your piece.

DEUTSCHE BLUMEN
Another name for Dresden flowers: stylised flowers painted originally at the Meissen factory.

DRAGGING

A sensation felt when the brush has not enough oil to make the paint flow properly.

DRESDEN

Town in Germany where the Meissen factory was founded in 1710 and which was the first and for many years the finest porcelain factory in Europe. The words Dresden and Meissen have become synonymous, but when buying antique porcelain beware of any pieces with just the word 'Dresden' stamped on the back as this is an area in Germany where many porcelain factories sprang up. The true Meissen has the unmistakable 'crossed swords' motif, but there are many fakes.

DRESDEN FLOWERS

Stylised flowers whose petals and leaves are painted with disciplined brush strokes, as painted by the Meissen artists, often with little bugs and butterflies to cover up impurities in the glaze.

DULL COLOURS

The result of underfiring; re-fire at a hotter temperature.

DURABILITY

Colours and glazes resistant to acids and alkalies, which would otherwise result in colour loss and could be harmful on wares which will be eaten from.

DUST

The china painter's enemy, it will cause little collections of paint around it. The dust will fire off but will leave little pools of colour which will mar your work, and are impossible to remove.

DUSTING (OR DRY DUSTING)

Method of applying powdered colour over a dry but unfired painted surface which when fired will give a beautiful opaque appearance with a high gloss; one of the most difficult processes to master, calling for a great deal of skill and practice. Beloved of the old European factories.

EARTHENWARE

An opaque ware which doesn't allow the light to pass through, and has a fairly 'open' body which easily absorbs water. Coarse earthenware was made as long ago as 5000 BC and consists of 25 per cent Ball clay, 25 per cent China clay, 35 per cent flint and 15 per cent China stone. It is bisque fired at 1150°C and Glost fired at 1100°C.

EGGSHELL

Hard paste porcelain of exceptional thinness, originated in China.

ELEMENTS

The coils of heat-conducting material used to heat the kiln.

ENAMELS

Pigments which are made from metallic and mineral oxides and used to decorate porcelain and china, often called onglaze enamels when used by the china painter because they are painted over the glaze.

ENGLISH BONE CHINA

Beautiful hard-bodied white ware with a lovely high glaze, which fires at a slightly lower temperature than porcelain (approximately 780°C). Many painters abroad are wary of using china to work on, believing it to be unreliable in firing, but this is not so. If good quality china is selected it fires as successfully as porcelain, but with the added bonus of a high glaze.

ERASER (GOLD)

Rubber used to remove gold and lustres after firing.

ESSENCE GRASSE

French vegetable oil used as a china painting medium.

ETCHING

Method of removing the glaze on china for special effects.

EUROPEAN STYLE PAINTING

Usually this term refers to Dresden style painting or designs painted leaving a white background.

FAÏENCE

Tin glazed earthenware named after the town Faenza in Italy where this ware was first made, and often called majolica or maiolica.

FAIRY LUSTRE

The type of design made famous by the Wedgwood

factory where fantastic fairyland scenes were painted in lustres and then outlined in gold; Daisy Makeig-Jones was a noted artist of this technique.

FAT OIL
Medium derived from evaporated turpentine, made by taking approximately 1 pint of pure turpentine and allowing it to evaporate in a warm place covered with muslin. It takes approximately 6 weeks for this to reach the correct consistency. It is the main medium used by artists in commercial factories in conjunction with clove oil to keep it open. It is diluted with pure turps and is a fast drying medium.

FELDSPATHIC GLAZE
Translucent glaze made from powdered feldspar mixed with other ingredients and fired at a very high temperature. Coloured with oxides and metals, this glaze was first perfected by the Chinese.

FILTERING
Making soft brush strokes in the background around the design to create atmosphere.

FINDINGS
Name describing the metal settings for jewellery.

FINGERMARKS ON GOLD
Made by handling the gold whilst warm which can be difficult to remove.

FIRING
The baking of the china in the kiln making the design permanent.

FLAMBE
Lustrous rich red glaze, first developed in China and later used in Europe from the late nineteenth century especially by the Berlin factory in Germany and later by Royal Doulton in England.

FLAT SHADER
Brushes with flattened shape, much loved by naturalistic painters.

FLUX
Agent added to china paints to help them fuse with the glaze, which can be used mixed with your usual medium to give a very glossy finish after firing. Beware using the flux with some reds, however, as it will bleach all the colour out.

FOCAL POINT
Point of main interest in design.

FRAME UP WITH THE BRUSH
To apply background around the main design making it more prominent.

FRIEZE
Continuous border design.

FURNACE
Another name for kiln.

FURNITURE FOR KILN
The shelves (bats) and props used inside the kiln.

FUSING
The action of the glaze and decoration adhering together. The decoration is absorbed as part of the glaze, making the design permanent.

GADROONED EDGED
Scalloped convex curves applied to edging.

GENKLENE
A dry cleaning spirit obtained in the UK and used as a substitute for alcohol, obtainable only from china painting suppliers.

GENUINE TURPS
Pure spirit of turpentine sometimes called gum turps.

GILDING
The art of applying gold to porcelain and china.

GLASS PAINTS
Specially prepared enamels for use on glass painting, which need to be fired at different temperatures to the china colours.

GLAZE
Glassy substance applied to biscuit ware to give a water-repellent covering. China is decorated over the glaze, while pottery is often decorated before the glaze is applied (called underglaze decoration). Glaze is made from purified sand or other ingredients suspended in water. Glazes were used in the Middle East over 5,000 years ago.

GLAZED WARE
Ceramics which have had a layer of glaze fired on.

GLOST FIRE

The firing in which the glaze adheres to the biscuit ware.

GOLD

Pure precious metal which comes in various forms for the china painter; liquid bright gold, burnishing gold, or Roman gold, most often in a liquid base, but it can be purchased ready mixed in little pats which have to be used with lavender oil. Gold leaf is not used by the china painter but can be used in the restoration of antique ceramics as it does not need to be fired.

GOLD BRUSH OR BURNISHER

Glass fibres held together by a string band and used to burnish the fired gold.

GOLD COLOURS

These are the colours which contain quantities of gold in their manufacture e.g. pinks, rubies, and purples, which makes them more expensive. The more gold they contain the more expensive they are, so they are usually sold in small quantities to keep the cost down.

GOLD ERASER

Rubber to remove unwanted gold smears; also removes lustres and platinum.

GOLD FACILITATOR

Another name for gold thinners, thinning agents for precious metals.

GOLD FLAKING

As for gold sandblasting, but can be done with an etching cream instead.

GOLD LEAF

A very thin sheet of pure gold used in restoration work.

GOLD PEN

A felt-tipped pen impregnated with gold, suitable for drawing scrolls, edges, etc., you get what you pay for in gold quality.

GOLD SANDBLASTING

Method of removing glaze with the use of little glass beads, for use with gold designs.

GOLD SHELL

A little porcelain dish with a small well to hold gold whilst in use. It has its own lid and is an economical way to store your precious gold while in use. The remaining gold can be left in the shell and used at a later date if thinned with the correct thinners. This is one of the china-painting aids we cannot do without once we have used them.

GOLD SMEARS

Purple marks left where gold has been unsuccessfully removed, which can be erased with a gold rubber.

GRAINY COLOURS

Onglaze enamels which have been insufficiently mixed.

GRAPHITE PAPER

Carbon-like paper with a graphite covering, perfect for tracing on china but difficult to obtain from shops. In the UK get it from china suppliers.

GREENWARE

The ware before glazing.

GRINDING

Method of mixing the powdered colour with an oil medium.

GROTESQUES

Fanciful motifs similar to arabesques but with human figures.

GROUNDLAYING

Method of achieving a dark glossy background in one firing, which is undoubtedly one of the most difficult techniques in china painting. Some colours will work better than others: the gold colours are the most difficult to work with, and yellow is the easiest. The area to be groundlaid is oiled and then padded with silk and the powdered colour is applied with cotton wool (see more detailed information in the appropriate section).

GROUNDLAYING OIL

Oil used in conjunction with the above technique can be specially purchased, or fat oil may be used diluted with turps. The commercially prepared groundlaying oils often have oil of tar in their manufacture.

HALO LUSTRE

Specially prepared liquid which gives the typical 'halo' effect when applied to wet lustres.

HAND REST

Small wooden bridgelike shape made to rest the hand on whilst painting.

HARD PASTE PORCELAIN

Has a greyish cast and allows light to pass through it. The ingredients melt into a hard strong body over which the glaze fits very tightly. Colours lie more on top of the glaze than with bone china. Contents: 50 per cent china clay, 30 per cent china stone, 20 per cent flint. Bisque firing 900-1000°C, glost firing 1350-1500°C, decoration firing 800-850°C. Some porcelain is fired only once with the glaze. Soft paste porcelain is as above but the body is granular, as the ingredients do not melt together in the same way, and colours sink into glaze more. Hard paste is made mostly in Japan, France, and Germany, but was first made in China *circa* AD 750. The first European factory to make porcelain was Meissen in 1709.

HEAVY MEDIUM

Usually refers to thick mediums e.g. fat oil, copaiba.

HIGH FIRE

A high temperature in the kiln.

HIGHLIGHTS

Little light areas left or wiped out when you paint.

HIGH RELIEF

To make the enamel stand right out of the body of ware as in some *pâte-sur-pâte.*

HYDROFLUORIC ACID

Very powerful and dangerous acid for removing glaze on china, which will also remove fired colour. Safety precautions *must be adhered to.* Not a material to be handled carelessly.

IMARI

The name of a port in Japan where porcelain was shipped from. There is no factory called Imari but the porcelain was made at Arita and the name became synonymous with that of Imari. Made from the late seventeenth century onwards, it was richly decorated with flowers, figures, ships, etc., in underglaze blues, reds and golds. 'Brocaded Imari' is a term applied to the rich overall floral decorated pieces painted to resemble rich silk textiles.

IMPASTO

Term to describe paint applied with palette knife in thick layers.

INDIAN INK

Sometimes used to sketch the initial design onto china. It will fire away in the kiln, and is not as satisfactory as chinagraph pencil in my opinion.

IN-GLAZE

Under the glaze.

IPAT

International Porcelain Art Teachers Inc. based in the USA. A non-profit-making organisation evolved to further the art of porcelain painting. See list of organisations in separation section. Bi-annual Convention.

IRIDESCENCE

Term used to describe the metallic effect of lustres.

IRON COLOURS

The colours include brown, red, and violet of iron, so-called because of the iron ingredients in manufacture.

IRON OXIDE

Used in the above.

JEWELLING

Name for the application of raised paste and enamel which is then coloured to resemble precious jewels. The finest examples were made at Sèvres, Meissen, St Cloud, and later at Worcester.

KAKIEMON

Sakaida Kakiemon, one of the most famous Japanese porcelain makers and artists, whose style was named after him and consisted of decorations in bright clear colours, namely orange-red, lilac-blue, green and sometimes a discreet use of yellow, and of course gold.

KAOLIN

Means 'High Ridge' in China, where the material was first found.

KASHMIRI DESIGN
A Paisley style of decoration.

KILN
Pronounced 'kil', needed to fire the pieces after decoration to make the design permanent. Several types are available and all are easy and safe to use, if manufacturers' instructions are carried out. (Either electric or gas.)

KILN SITTER
A device fitted to some kilns to collapse a small cone at the required temperature, which will switch off the current so that overfiring cannot occur.

KLEIN
Catarina Klein, b. 1861, a water-colourist who studied at Berlin Academy and later at Dresden. Her designs are avidly collected by china painters.

LATTICEWARE
Pieces with pierced edges.

LAVENDER OIL
Oil of the lavender plant, very aromatic and used to make mediums more 'open'.

LEADING LADY
The main focal point in a floral design.

LEAVING TO 'SET UP'
Time allowed after painting to allow the paint or oil to settle.

LEMONADE PEN MIX
Pen medium obtained by mixing fizzy drinks with powdered colour to give a fast drying pen mix.

LIGHT AND SHADE
A good painting will need a little of both for balance. Do not forget the 'reflected' light from lighter portions under design, e.g. at the edge of berries.

LIMITED EDITION
Hereby hangs a tale. Strictly this means limiting the number of pieces produced either by number or by a particular time span. Pieces can be limited to small editions where each one is numbered, say, from 1-250, or 500. These pieces are usually worth collecting if made or painted by a particular well-known factory or artist, however certain editions are limited to the number of orders received by a certain date, which results in pieces being produced by the thousand. Of course, large editions are never handpainted except for the gold band around the plate. I think the suitable term here is 'you get what you pay for'.

LIMOGES
Famous French area for porcelain factories. The name 'Limoges' on its own means little as it is just the name of the area where the pieces are made; the factory mark is most important, e.g. Haviland.

LINER
Brush with long pointed hairs to give fine line.

LIQUID BRIGHT GOLD
As the name suggests, this is gold in liquid form which fires bright and shiny.

LITHOGRAPHS
Lithography is a method of printing designs onto paper to give us decals or transfers.

LOADING THE BRUSH
Filling the brush with colour.

LOW FIRE
A cooler firing in the kiln, recommended for firing reds, lustres, gold etc., approximately 750-760°C.

LUSTRE
From the Italian *lustro*, I shine. Made from metallic oxides suspended in liquid which fire away during the kiln process leaving a coat of iridescent metal. Lustres do not keep well if stored too long.

LUSTRE THINNERS
Liquid used to thin the thickened or congealed lustre, which has a short shelf life.

LUSTRE RESIST
Plastic-based material used to cover areas not to be decorated with lustre. Paint on and leave to dry thoroughly and then proceed with the painting, peeling off the resist before firing.

MAJOLICA
Tin-glazed earthenware sometimes called faience, which was used before the making of porcelain, as the glaze was white.

MARBLING

Method of giving a marbled effect, often used with lustres. A special liquid can be bought to make ordinary lustre 'separate'.

MASKING FLUID

Liquid used to mask out areas not to be painted.

MATT

Name applied to porcelain or colours with no glaze.

MATTING AGENT

Material in powder form, purchased to give colours a matt finish when mixed with regular paint.

MATURING

Leaving the kiln at a high temperature to 'soak', to make the colours achieve their fullest potential.

MAZARINE BLEU

Deep royal blue beloved of antique painters.

MEDALLION

Reserved panel on porcelain for special design. Often the little jewellery blanks are called medallions.

MEDIUM

Simply the name given to any oil used to facilitate china painting (see appropriate section in book). There is no mystery to this term which is just another name for oil. Often this term confuses beginners who think it is something special.

MEISSEN

The factory in Germany where European porcelain was first made in 1709.

METALLIC OXIDES

Metals used in the manufacture of onglaze enamels.

MILCHGLAS

Opaque glass with milky appearance, in the mid-eighteenth century it was produced as imitation porcelain.

MILK MEDIUM

Mixture of milk and powdered colour to make a pen medium.

MING

Nationalistic dynasty which ruled China from 1368-1644. The general tendency in the arts was directed to lacquerware, textiles and metalwork, but this name is mainly associated with porcelain, which ousted pottery in the Mandarin houses. The finest Ming dates from the early periods when blue and white wares were produced – later other colours were introduced.

MINERALS

Natural ingredients found in the ground and used with pigments and flux to make our colours.

MINIATURES

Name given to very small pieces often loved by collectors.

MIS-SHAPES

Often our porcelain blanks are 'seconds' and we have to be grateful for what we can get in a lot of cases. The odd flaw here or there can often be painted over, but pieces that are badly mis-shapen should be avoided as they are never satisfactory; typical examples are vases that lean, lidded boxes which do not fit, cups which do not fit the saucer, etc. Do not blame the suppliers for this but do examine your purchases carefully when you buy them, and never blame your teacher for anything mis-shapen after firing – it will have been badly shapen before but you did not notice.

MIXING MEDIUM

The oil used to grind the onglaze colours.

MONOCHROME

Painting consisting of several shades of one colour.

MONOTONE

Painting consisting of one colour with no variation.

MOTHER-OF-PEARL

Pearly finish associated with mother-of-pearl lustre.

MUFFLE KILN

Low temperature kiln.

MULLER

Instrument used with a slab of ground glass to mull or grind those stubborn gold colours.

NATURALISTIC PAINTING

A term used by china painters to describe the style of painting where a subtle background is added rather than leaving it white.

NOXIOUS GASES
Poisonous gases and fumes which escape from kiln during firing. Never work in the same room whilst the kiln is being fired: the gases given off with gold and lustres are particularly evil smelling and dangerous.

NYON
Famous porcelain factory in Switzerland noted for its decoration of small sprigs of flowers.

OEIL DE PERDRIX (PARTRIDGE EYE)
Decoration used at Sèvres consisting of patterns with a large dot in the centre surrounded by smaller dots, repeated many times to give a unique all-over decoration.

OILS
For details of each see the relevant section in the book but the most used ones are copaiba, lavender, cloves, turps, etc.

ONGLAZE ENAMELS
Powdered colours used to decorate over the glaze of china and porcelain, which are also available in water-based form. Made from metals and minerals.

ONE-FIRE DECORATION
As the name suggests, pieces which are painted and fired only once – more commonly seen with Dresden-style decoration.

OPEN MEDIUM
One which takes a long time to dry or doesn't dry at all until fired.

ORIGINAL
Designs which you have made up yourself and not copied or traced. A term used to describe the prototype of a design from which others are copied.

OUTLINING MEDIUM
Pen oil.

OVERFIRED
Fired in too hot a temperature.

OVERWORKED
Painting which has had too much brushwork, and has a dull fussy appearance.

PADDING
Method of smoothing the painted colour with a silk pad or sponge.

PAINTING MEDIUM
The oil used to lubricate your brush before dipping into colour.

PAISLEY
Kashmiri designs much loved by Delft.

PÂTE-SUR-PÂTE
Method of using raised enamels and slip to form designs and scenes; it is built up to stand very much in relief from the body of the china and usually done over several fires. It may be engraved and shaped and is an extremely difficult and skilled process. The most famous artist using this technique was Marc Louis Solon, employed at Sèvres and later at Minton.

PATIENCE, PRACTICE AND PERSEVERANCE
The most important ingredients in this lovely artform.

PEEP HOLE
Cavity in kiln to watch the firing process.

PEN OIL
Oil used to mix with paint, making it suitable to flow through a fine point.

PERSPECTIVE
The three-dimensional aspect in a painting.

PETIT POINT
Type of painting resembling needlework.

PIERCED WARE
Plates with holes around the edge.

PLATE DIVIDER
Cardboard or paper circle with spaces marked to indicate the appropriate spaces required, a doily is an excellent alternative.

PLASTIC PAPER
Used in the making of transfers and also to paint on when china would be impractical, such as sending designs through the post. Paint on it exactly as you would on china; you can 'wipe-out' but do not go over it too many times – remember it is paper and not china.

PLATINUM
Precious metal which will not tarnish.

POINTILLISM
Designs built up and shaded with hundreds of dots – great fun to do.

POINT OF INTEREST
The main point or the point which catches the eye.

PORCELAIN
Strong hard-bodied white ware with greyish cast; see hard-paste porcelain and bone china.

PORTRAIT COLOURS
Specially formulated for portrait painting, although it is not really necessary to have special colours.

POSTURE
It is most important to have the correct posture whilst painting, otherwise you may get all sorts of physical complaints – get up and stretch occasionally.

POTTERY
Soft glazed ware usually decorated under the glaze. Opaque ware will not allow light to show through.

POUNCING OR PRICKING-ON
Charcoal powder used in a pad of silk to 'pounce' through pricked tracing paper to outline design for painting. Pouncing is also used to describe padding with a sponge to obtain a grounded effect.

PRECIOUS METAL ESSENCE
Liquid specially manufactured to thin gold and silver; do not use turps.

PROFESSIONAL
An artist who paints and sells work for a living.

PYROMETER
Mechanical aid that takes the guesswork out of firing, a temperature indicator and controller.

QUILL
Handle of brush or pen.

RAISED ENAMEL
Use with relief oil. A *white* enamel powder to make raised designs.

RAISED PASTE
For use with gold. A *yellow* powder to make raised designs.

REFLECTED LIGHT
The light reflected from other light areas, e.g. on the bottom of fruit on the shaded side, to give rotundity.

RELIEF GOLD
Gold used with raised paste.

RELIEF WHITE
White enamel.

RESERVED PANELS
Panels left in reserve for special decoration, usually with small flowers.

RESIST FLUID
Masking fluid used with lustres and groundlaying paint.

RHYTHM
The general flow of the design, causing the eye to wander over it as a whole.

ROCOCO
Elaborate style of decoration.

ROMAN GOLD
Gold containing flux similar to burnishing gold, often purchased in little pats, and needing to be fired and burnished.

RUST REMOVER
Acid often used to remove unwanted fired colour.

SABLE
Animal from which we get our sable brushes.

SAFETY
Rules of which *must* be obeyed as some of our materials are highly toxic. The powders should not be used in large quantities without the use of a face mask, especially when groundlaying; it is the colour you cannot see, that is, the powder in the atmosphere which is dangerous.

SANDPAPER (WET AND DRY)
Used to gently smooth the ware after firing.

SANG DE BOEUF
Brilliant deep plum red glaze on old Chinese wares.

SATSUMA
Japanese pottery.

SCROLLS
Pretty decorative shapes made up of curves.

SCROLLER
Elongated brush used for applying bands to china.

SELENIUM
Used in the manufacture of some colours, mainly reds.

SÈVRES
Important French porcelain factory.

SGRAFFITO
Method of incising the clay before firing. Also used to describe the scratching out of the design from wet paint.

SHADOW LEAVES
The leaves other than the ones in the main design, usually painted in subdued shades into a wet background.

SILK PAD
Piece of pure silk covering a wad of cotton wool to make pad, for obtaining smooth colour.

SILVER
Precious metal available in liquid form for decorating china. Fires with a bright silver finish, and needs polishing occasionally to prevent tarnishing.

SLIP
Clay in its liquid form.

SPIRITS OF TURPENTINE
Pure turpentine as opposed to the household variety.

SPRIGGED DESIGN
Pieces decorated with small flower sprays giving a delicate airy design.

SPRIGGED WARE
English style of ceramic ware decorated with applied relief designs; the reliefs were pressed into intaglio moulds and fixed to the vessel with liquid slip.

SQUARE SHADER
Brush with flattened hairs.

STACKING
The art of loading or stacking the kiln for firing, a skilled job in the industry.

STICKING
Bone china, if allowed to touch whilst firing, will stick together. This does not happen with porcelain as the glaze is harder.

STILTS
Props used inside the kiln to support shelves and wares.

STIPPLING
Special effect painted with flat tipped brush.

STRENGTHEN
Apply more colour to design and fire again.

STUDIES
Designs printed especially for our use giving detailed instruction and sketches, etc.

SUGAR MIXTURE
Sugar and water mix making a fast-drying liquid to flow through the pen.

SWEEP BACKGROUND OVER DESIGN
Strokes with a broad brush to 'pull' the background colour over part of design whilst still wet, giving the appearance of making part of the design recede into background. Very effective when done well.

TECHNIQUE
Particular style of painting.

TERRACOTTA
Red-brown coloured clay used in pottery.

TEST FIRE
Preliminary tests with colours painted over each other to see how they react together.

TIN GLAZED WARE
Majolica, Faïence, Delftware.

TINTED BACKGROUND
Light coloured background applied and fired before adding design.

TOP LOADING
Kiln which has an opening at the top as opposed to the front.

TRANSFERS
Another name for decals, manufactured with printed designs and used mostly in the industry to obtain identical results on each piece. First used in 1756.

TRANSLUCENT
Allows the light to shine through.

TUBE LINING

Liquid slip applied to biscuit ware in patterns, which are then fired and glazed and painted. A popular technique with Charlotte Reade in the 1930s.

TUCK-INS

Strokes used with a side-loaded brush to shape flowers by making the background darker under the leaves and blossoms. The strokes are taken right under the flowers etc, hence 'tucked in'.

TURPENTINE

Essential ingredient of china painting used to clean brushes and thin colour.

UNDERFIRED

Fired in kiln at too low a temperature.

UNDERGLAZE DECORATION

Decoration painted before the glaze is added, mostly used with pottery.

UNFLUXED GOLD

Usually purchased in little pats and containing no flux, so to make it adhere it is painted over raised paste. Burnish after firing.

UNICAL PAPER

Paper with plastic coating used for making transfers.

VENT

The airhole in the kiln.

WARM COLOURS

Reds, oranges, and yellows.

WASH OF COLOUR

Layer of light colour applied with a flat shader.

WET IN WET

The art of painting one layer of wet colour over another.

WHINK

Rust remover containing hydrofluoric acid which will remove fired colour.

WHIRLER

Another name for banding wheel.

WINDOWS

Little area of light left in the background to give airy effect.

WIPE-OUTS

Method of taking off wet colour with cleaned brush, exposing the white china below.

Organisations and magazines for china painters

Dear China Painter,

You may be working alone in isolated areas where there is little or no contact with other painters. I feel that it is very important to keep in touch through clubs and magazines and it is for this reason that I am including the following organisations for your information. I have indicated a contact address in each case, which will enable you to find out what is going on in your area and will enable you to obtain details of any courses and teachers, etc. When I returned to England from Australia ten years ago it took two years before I came into contact with any other painters and this feeling of isolation may often deter the would-be china painter from continuing in our lovely art. This must not happen in the future, and with the help of our clubs and magazines etc., you will be able to obtain any information you require and hopefully go from strength to strength with your china painting making many new friends along the way − that's what it is all about. If you have enjoyed reading and working from the book I will be pleased to hear from you as indeed I have from readers of my first book, some of whom have had to work alone in outback areas miles from anywhere. It has been a pleasure writing the book and I hope you will continue to enjoy it.

Happy painting − Sheila Southwell

(When writing to any contact addresses a stamped addressed envelope will be appreciated where possible.)

British China & Porcelain Artists Association (BCPAA)

Magazine: *The British China Painter*

Contact: Sheila Southwell
7 West Street,
Burgess Hill, Sussex RH15 8NN
England
Tel: 044 46 44307

Westfield House China Painting School

Magazine: *Westfield House News*

Contact: Celia Shute
Westfield House,
Westfield Grove,
Wakefield, Yorks,
England

Pairo China Painters

Contact: Iris Saunders,
3 Meadsway,
Great Warley
Brentwood, Essex,
England

Scottish Assoc. of China Painters

Contact: Mrs Gray
62 Crawford Road,
Milngarie
Glasgow G62 761,
Scotland

The China Decorator (Monthly magazine)

Contact: *The China Decorator,*
3200 N. Shingle Road,
Shingle Springs,
California 95682
USA

International Porcelain Art Teachers Inc. (USA)

Magazine: *Porcelain Artist*

Contact: IPAT Executive Officer,
7430 Greenville Avenue,
Dallas, Texas,
USA

World Organisation of China Painters

Magazine: *The China Painter*

Contact: Pauline Salyer,
3111, 19th Street,
Oklahoma City,
Oklahoma 73107,
USA

UBAP Brazil

Contact: R. Pamplona,
710/40 & 46,
St. Paulo 01410
Brazil

Porcelens Maling (Norwegian magazine)

Contact: Liv Ogaard,
Ullevalsveien 113 B,
Oslo 3,
Norway

Australian Porcelain Decorator (quarterly magazine)

Contact: Editor,
Celia Larsen,
P.O. Box 13,
Asquith,
Sydney,
N.S.W. 2078,
Australia

Suppliers of china painting materials

United Kingdom

Mid-Cornwall Galleries,
Biscovey, Par,
Cornwall PL24 2EG
Tel: 072681 2131
General supplies, teaching.

Keepsake Craft Products,
Whitebridge Lane,
Stone, Staffordshire ST15 8LQ
Tel: 0785 813135
General supplies, figurines.

Howe & Ware,
42 Gladys Avenue,
Northend,
Portsmouth PO2 9BG
Tel: 0705 661987
General supplies, kilns.

Held of Harrogate,
16 Station Parade,
Harrogate,
Yorkshire
Tel: 0423 504772
General supplies, bone china, kilns.

Potterycrafts Ltd,
Campbells Road,
Stoke on Trent,
Staffs ST4 4ET
Tel: 0782 272444
General supplies, kilns.

Also at:
105, Minet Road,
London SW9 7WH
Tel: 01-737 3636

Fulham Pottery,
Burlington House,
184 New Kings Road,
London SW6 4PB
Tel: 01-731 2167
General supplies, kilns.

Galaxie Studio,
90 Rectory Grove,
Leigh on Sea,
Essex
Tel: 0702 712788
E.S. Colours, general supplies.

West View Studio,
Main Road,
Welton le Marsh
nr. Spilsby,
Lincolnshire
Tel: 075 485 388
E.S. Colours, general supplies.

Potclays Ltd,
Brick Kiln Lane,
Struria,
Stoke on Trent,
Staffs
Kiln specialists.

Recollect,
The Old Village School,
London Road,
Sayers Common,
Sussex
Doll-making courses, general supplies.

July Ceramics,
Unit 3,
The Barracks,
Newcastle under Lyme,
Staffs
Tel: 0782 637486
Personalised decals, supplies.

The Craft Centre,
Ganton,
Scarborough,
Yorkshire YO12 4NR
Tel: 0944 70132
General supplies, tea-shop.

H.R. Edge,
158 Star & Garter Road,
Longton,
Stoke on Trent,
Staffs ST3 7HN
General supplies, bone china.

Dorothy Wallace (BCPAA),
The Wallace Collection,
32 Esk Street,
Silloth,
Cumbria
Studies, supplies, teaching.

The Art Shop,
31 Albert Road,
Colne,
Lancashire
Tel: 0282 812235
General supplies, books, frames.

Deancraft Fahey,
12 Spedding Road,
Fenton Industrial Estate,
Stoke on Trent,
Staffs ST4 25T
Tel: 0782 414400
Colours and supplies.

Pat Norman (IPAT & BCPAA),
2 Russet Drive,
York
Videos, teaching, supplies.

Barbara Salisbury (IPAT & BCPAA),
123 Battenhill Road,
Worcester,
Worcs. WR5 2B4
Tel: 0905 351274
Videos, teaching.

Amy Ryder (IPAT & BCPAA),
36 Silverdale Road,
Frodsham,
Cheshire
Tel: 0928 33019
Videos, teaching.

Sheila Southwell (IPAT & BCPAA),
West Lodge,
7 West Street,
Burgess Hill,
Sussex RH15 8NN
Tel: 044 46 44307
Teaching, courses, china restoration.

Lenham Imports & Exports,
16 Ashdown Avenue,
Rottingdean,
Sussex
Plate stands of quality, vase and bowl stands, plate wires.

Westfield House,
Westfield Grove,
Wakefield,
Yorkshire
Teaching courses, supplies.

Europe

DENMARK
A/S Schjerning's Farver,
Oster alle,
Postbox 119,
Denmark 8400 Ebeltoft
Manufacturers of E.S. Colours, general supplies.

FRANCE
Établ. CERADEL,
19 rue Pierre Curie,
87004 Limoges Cidex
E.S. Colours, supplies.

GERMANY
C. Kreul,
Postf 229, 8550 Forcheim
E.S. Colours, supplies.

ICELAND
Handid,
Nybylavagi 18,
200 Kopovogi
Colours, supplies.

NORWAY
Global Hobby,
Collettsgt 33,
Oslo 1
Colours, supplies.

SWEDEN
GEFAB,
Store Sodergaten, 59,
221 01 Lund
E.S. Colours, supplies.

ITALY
Didakta,
Piazza San Done di Piave 16-19,
1-00182 Rome
Colours, supplies.

FINLAND
Sinooperi OY,
Sarkatie 3,
SF 01720 Vantaa
Supplies.

NETHERLANDS
E.S. Colours Benelux b.v.,
J.V. Krimpenwag 57,
Ind. Terr. Waarderpolder,
2031 CH Haarlem
E.S. Colours, supplies.

SWITZERLAND
Details from E.S. Denmark address above.

Other Parts of the World

CANADA

Tove Hansen,
1004, 10045-118 Street,
Edmonton,
Alberta
Supplies, general.

Camille Muller Studio,
48 Harjolyn Drive,
Islington,
Ontario

NEW ZEALAND

Strawberry Hill Studio,
P.O. Box 9650,
Newmarket,
Auckland

USA

Joyce Berlew
Country Art Studio,
Box 788, Dept. 5,
Moravia,
New York 13118
Brushes, general supplies.

Freddie's China Closet,
8970 Ellis Avenue,
Los Angeles,
California
Porcelain supplies.

House of Clay China Shop,
1100 N.W. 30th,
Oklahoma City,
Oklahoma

Renaldy's
277 Park Street,
Troy,
Michigan

Rynnes China Co.,
222 West 8 Mile Road,
Hazel Park,
Michigan 48030

AUSTRALIA

Gilberton Gallery,
2-4 Walkerville Terrace,
Gilberton,
S.A.

Porcelain Place,
3-5 Myagah Road,
Mosman,
Sydney, N.S.W.

Russell Cowan Pty Ltd,
128 Pacific Highway,
Waitara,
Sydney, N.S.W.

QUESTIONS AND ANSWERS

Q. How can I be sure when my paints are correctly ground and mixed?

A. When all grainy particles have been eliminated and paint is at a toothpaste consistency i.e., when it will not shake off the palette knife.

Q. Can I paint one coat of gold over another that hasn't been fired?

A. Yes. Apply an even second coat, not too thickly, and fire as normal.

Q. My gold is too thick – what can I do?

A. Dilute with a tiny drop of precious metal thinners, *never* turps.

Q. Does my paint have to be dry before I fire it?

A. No, you can fire it immediately.

Q. I painted a plate twelve months ago. Is it too late to fire it?

A. No, provided you have kept out the dust you can fire as usual.

Q. If there is a power failure during firing, will my pieces be ruined?

A. No, this will not affect your pieces at all, just re-fire in the normal way.

Q. What design is good for a beginner to use on a tea set?

A. A beginner should *never* attempt a tea or dinner set; only ruination of the china can result. Wait till you are more competent before tackling such a job.

Q. What is the difference between grounding and dusting?

A. Groundlaying is a method of achieving a rich dark background in one fire by applying dry sieved powdered paint over a layer of special grounding oil. Dusting is the application of powdered paint over the painted piece *after* drying and *before* firing, this gives dark accents where you want them in one fire, which is very tricky to do.

Q. Can I touch up the worn gold on an old piece?

A. Yes. Just apply the gold as usual and fire. But be aware that damage can result if the piece is very old.

Q. Can I re-touch with paint where the colour has chipped off?

A. You may be lucky, but usually once the colour has chipped off it takes the glaze with it so there is nothing for the paint to adhere to. You can try adding some flux to your ground colour, as this sometimes helps.

Q. After firing, some of the colour rubbed off and also my pencil marks were still visible. What did I do wrong?

A. Definitely not fired hot enough, there is no exception to this rule; use more heat.

Q. After firing, my colours all looked dull and not glossy.

A. Same answer as above – underfired; re-fire at a higher temperature.

Q. My colours look too pale after firing.

A. Too little paint used in mixing or too much oil used in painting; you can only have your colours as strong as the paint you put on. But it is better to have it this way than have it too heavy as you can add more colour on subsequent firings.

Index